IMAGES
of America

WINCHENDON

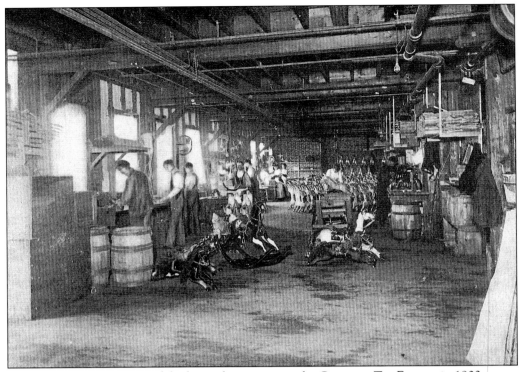
The trimming room of the horse department at the Converse Toy Factory in 1903.

IMAGES
of America

WINCHENDON

Glen C. Wheeler

ARCADIA
PUBLISHING

Published by Arcadia Publishing
Charleston, South Carolina

Printed in the United States of America

Library of Congress Catalog Card Number: 2007924193

For all general information contact Arcadia Publishing at:
Telephone 843-853-2070
Fax 843-853-0044
E-mail sales@arcadiapublishing.com
For customer service and orders:
Toll-Free 1-888-313-2665

Visit us on the Internet at www.arcadiapublishing.com

Contents

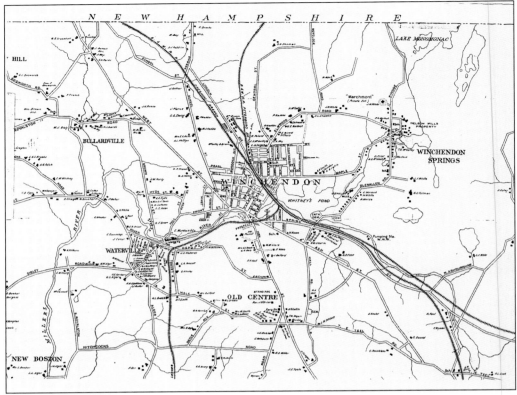

This map of Winchendon dates from 1906.

Introduction

Winchendon is the northernmost of the three border towns of Worcester County, bordered by Ashburnham on the east and Royalston on the west. There are more than 26,295 acres of land in Winchendon, with plenty of open space and woodlands. The highest point of land is Mount Pleasant, which is off High Street by the Winchendon Health Center. The elevation is 1,408 feet above sea level and the view on a clear day is one of great beauty, encompassing Mount Wachusett and Mount Monadnock.

In order to obtain a fitting starting point, we must go back to the date of the organization of the town. In 1724, Jabez Fairbank and a scouting party from Groton made their way to Mount Watatic, Lake Monomonack, and Pack Monadnock. It is quite probable that these were the first white men to explore this region.

When the hostilities between the Canadian French and the colonists came to an end, some settlements were made in Worcester County, but the land now belonging to Winchendon was still an unbroken wilderness. The Colony of Massachusetts wanted to give grants of land to the men who had served in the expeditions against Canada. On June 18, 1735, a tract of land 6 miles square was laid out in sixty-three shares. Of the sixty-three shares, one was to be used for the ministry, one for the school, and one for the first settled minister. The other sixty shares were to be divided, with preference given to the descendants of the soldiers who served in the expedition to Canada in the year 1690. The only petitioners named in the grant were Abraham Tilton, Captain John Hobson, Captain Joseph Choate, and the Honorable Thomas Berry. A committee was formed to admit grantees and to locate the settlement that was to be called Ipswich, Canada. In June of 1737, the committee went to locate and fix the boundaries of the settlement. Other expeditions were made in the following years to lay out roads, build bridges, and select a site for the proposed meetinghouse.

About nine years passed before more progress could be made, owing to continued hostilities with the French and Native Americans. But with peace secured in 1751, efforts were renewed to occupy the land. By 1753, there were about ten families in the settlement surrounded by thick forests, Native Americans, and wild animals. The settlers petitioned the Massachusetts Colony for aid and protection in 1755.

Old Centre, located off High Street, was the site chosen for the meetinghouse and in 1761 it was agreed to build one 35 feet wide and 45 feet long. The area chosen occupied 5 acres and would also have a burying ground and training field.

In the year 1763, the settlers took steps to apply to the general court to incorporate the town. It is highly probable that Winchendon got its name from a small town by that name in England. (Governor Frances Bernard of the Colony of Massachusetts, who gave Winchendon its name, had an interest in the town of Winchendon, England.) On June 14, 1764, the Plantation of

Ipswich, Canada, was incorporated into the town of Winchendon. Also in 1764, the inhabitants of the town assembled in the house of Richard Day, who was chosen as the moderator of the first town meeting.

In July 1776, the town of Winchendon unanimously resolved to support the continental Congress in its bid for independence from Great Britain. After the Revolution, Abel Wilder represented the town in Cambridge during the drafting of a new state constitution. Wilder then became the first state representative of the town of Winchester.

The earliest development of industry in the town came with the building of the gristmills and sawmills. About 1831, the production of cotton goods was introduced in Winchendon Springs, and in 1843 this enterprise was passed to Henry Upham and Joseph and Nelson D. White. The Millers River, which supplied the power needed to run the factories, formed the foundation of the town's success. The wooden-ware industry was influenced by the abundant growths of pine forests, and in 1827 Captain Ephraim Murdock built one of the first mills for the manufacture of tubs, pails, and other wooden ware. In 1846, Baxter D. Whitney built a dam and erected a factory on the present-day site of the Goodspeed Machine Co. for the manufacture of woodworking machinery. In 1847, the Cheshire Branch of the Boston & Maine Railroad was opened for business, thus affording an easier means of transportation for materials and finished goods.

For the first fifty years, the history of the town was focused on the Old Centre. The church, parsonage, store, tavern, and other buildings were located here. The opening of the railroad in 1847 influenced the growth of the present town center. Between 1870 and 1875, three other railroads entered the town, making it accessible and providing excellent shipping conditions.

In 1843, Ephraim Murdock, Esquire, erected a building at the junction of Front and School Streets known as the Winchendon Academy that was to be used for more advanced studies than could be provided in district schools. Upon the death of Captain Ephraim Murdock in 1882, the town received a donation of the needed monies to erect a new high school. In 1887, Old Murdock—as it is called today—was dedicated and opened for use on Murdock Avenue.

It is not possible in this short history to write in detail about the many businesses and people that have made Winchendon prosper. Some of these people, such as Mr. Charles Beals and Morton Converse, are mentioned here, along with civil servants and other professional people. Although Winchendon does not have the industry that it once did, we still have a rich and interesting record of past achievements and a future that must be regarded as promising.

One

Winchendon
Celebrating 150 Years

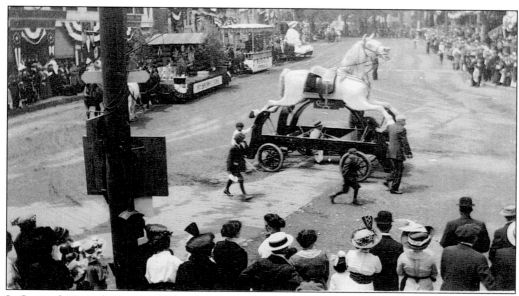

In June of 1914, the town of Winchendon celebrated its 150th anniversary, and the Converse Factory gave birth to the Toy Town Rocking Horse. The horse's construction was the work of many people. It was designed by Fred Dwelly; Charles Tenney and Jesse Bezio had the job of building the body; and John Damon painted the horse. A number of other Converse employees did the routine work and helped give Winchendon the name "Toy Town."

Official Program

of

the

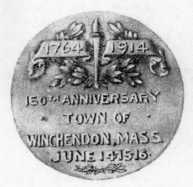

One Hundred and Fiftieth Anniversary Celebration of the Town of Winchendon Massachusetts

1914

Sunday June 14 Monday June 15
Tuesday June 16

GENERAL COMMITTEE
Appointed by Vote of the Town, March 8th, 1913

ELISHA M. WHITNEY, Chairman, WILLIAM H. BROWN, CHARLES M. DAY
NELSON D. WHITE, ELLIOT S. TUCKER, Secretary

Sunday, June 14th

Forenoon

Services appropriate to the day will be held in all the churches.

St. Mary's Church

9.15 **High Mass** for French speaking people, Rev. Dr. Cayer will preach.

Rev. Fr. Hackett will say Mass.

First Congregational Church

10.45 At Winchendon Center, the pastor, Rev. G. W. Jones will speak.

First Baptist Church

10.45 Sermon by the pastor, Rev. Sumner Bangs

This is the official program of the 150th anniversary celebration of Winchendon.

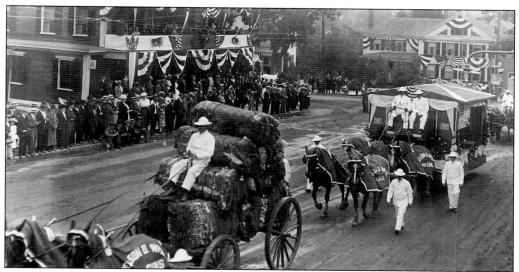

At 10:45 am the giant Industrial and Civic Parade began. Nelson D. White and Sons, Cotton Manufacturers, was a very important industry. The first wagon contained bales of raw cotton, the second wagon was draped with blue denim which was manufactured by them, and the blankets on the horses were of the same material. The picture was taken in front of the American House Hotel, where Cumberland Farms is located today.

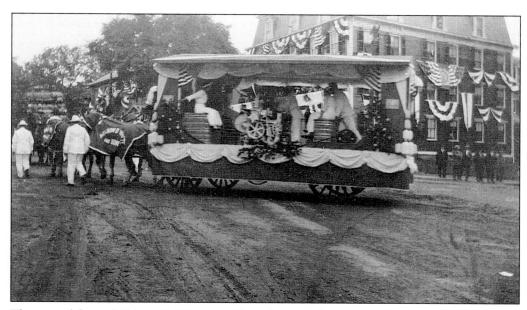

The second float of Nelson D. White and Sons showed a loom in action.

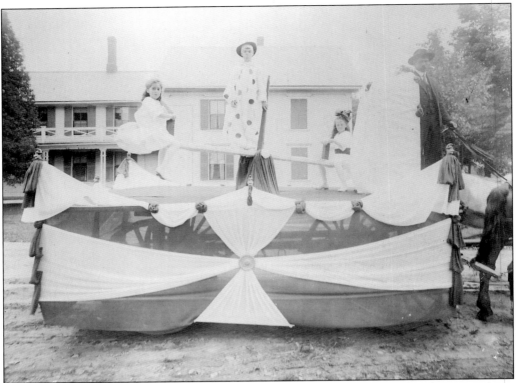

Mason and Parker Manufacturing produced toys. The float was drawn by four horses, and was decorated in red and white material. The clown was George Speare, the son of the general manager, A.O. Speare. The two girls were Emily Crofts and Helen Dempsey.

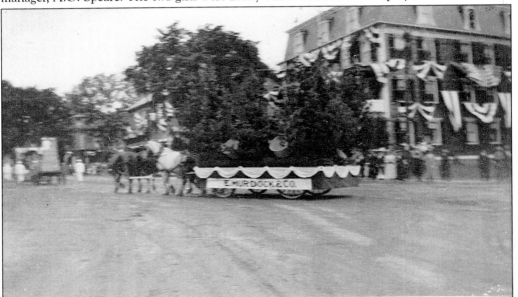

The E. Murdock & Company float was outlined with small trees, with tubs, pails, and washboards between the trees.

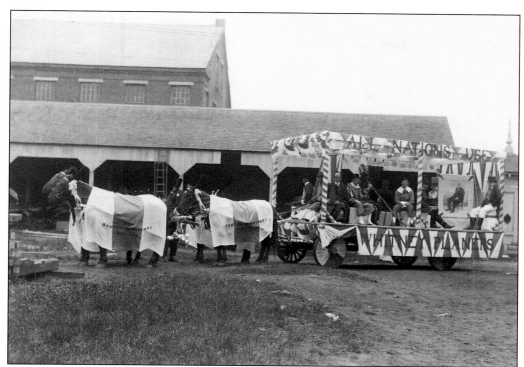

This is the Baxter D. Whitney and Sons float, showing representatives of different nations dressed in the costumes of their countries. The picture on the float is of Baxter Whitney, who was to be ninety-seven years old that year.

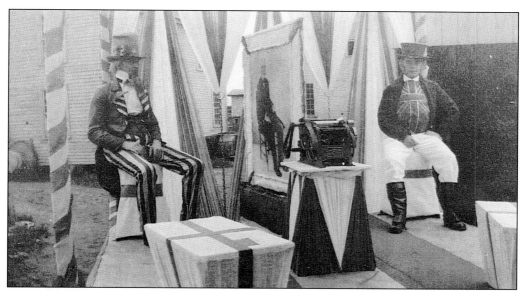

This is another picture of the Baxter D. Whitney and Sons float, showing some of the countries that were represented on the float. On the left is the United States, in the center is a picture of Baxter Whitney, and on the right is Great Britain. Whitney planers were known worldwide.

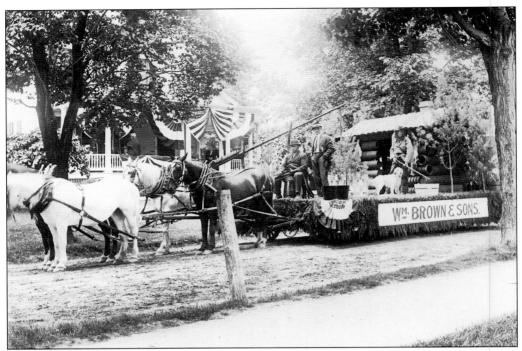

The Wm. Brown and Sons float was decorated with red, white, and blue tubs. They manufactured woodenware. The log cabin was made of pails, with a well in front. The driver's seat was a wooden tub.

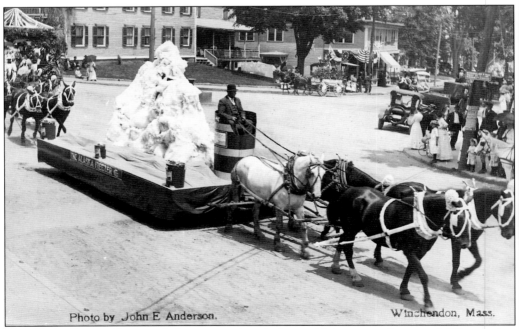

Photo by John E Anderson. Winchendon, Mass.

The Alaska Freezer Company's float was a giant iceberg with ice cream freezers of different sizes all around it. This picture was taken at the intersection of Front and Central Streets.

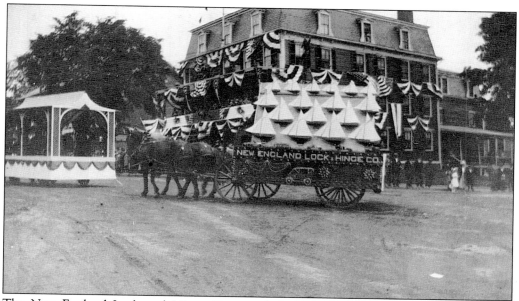

The New England Lock and Hinge Company's float showed the steel toys and hardware they manufactured.

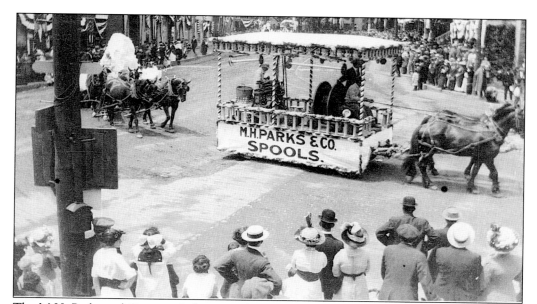

The M.H. Parks and Company's float was decorated in red, white, and blue. The float showed various spools and bobbins made by the company.

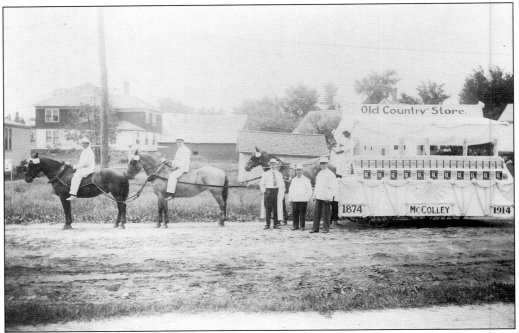

The Old Country Store float, made by H.W. McColley, had a pink and white float showing the lines of goods carried in his store.

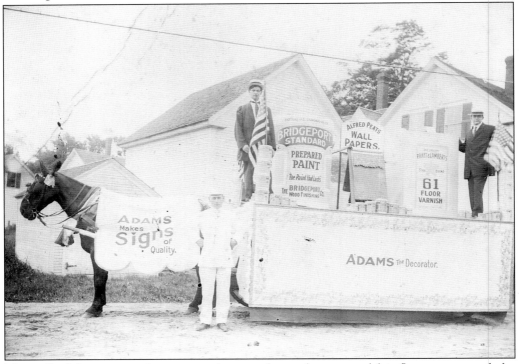

Morris E. Adams was a decorator, painter, and paperhanger, and his float represented the branches of his business.

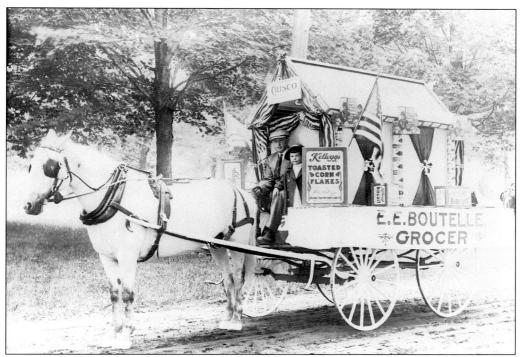

E.E. Boutelle's float represented some of the items in his grocery store.

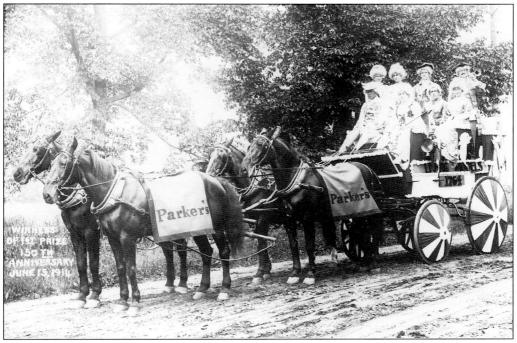

The float representing F.H. Parker's Dry Goods store won first prize in the merchant category. His clerks were dressed in period costumes from 1764, with the carriage decorated in yellow and white.

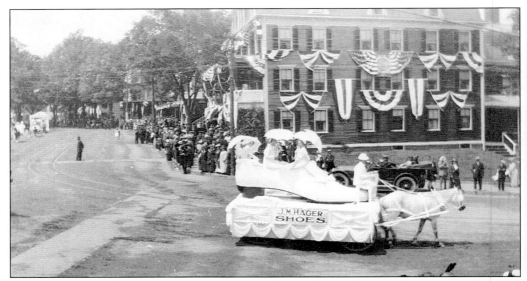

J.M. Hager, who sold shoes, boots, and galoshes, had a float with a very large shoe, filled with pretty girls.

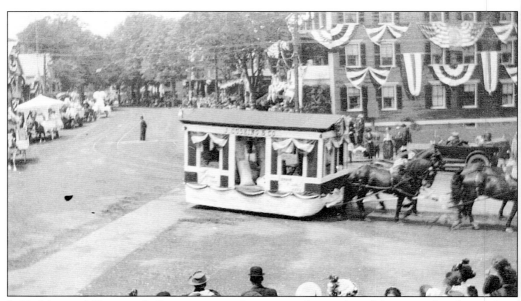

J. Cushing and Company's float represented a store with samples of their merchandise such as hay, straw, grain, and poultry feed.

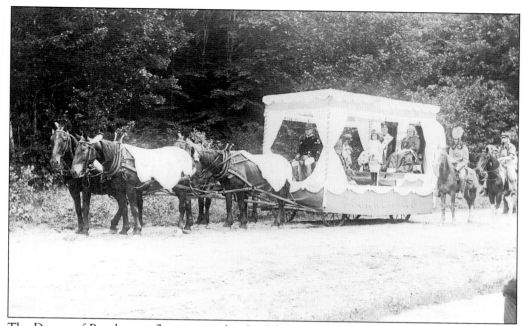

The Degree of Pocahontas float was in the third division of the parade, which was made up of "Patriotic and Fraternal Organizations." The float showed Pocahontas being introduced to the king and queen of England. The Degree of Pocahontas is the women's auxiliary of the Order of Red Men. The first council of this degree began in 1887, in Philadelphia, Pennsylvania.

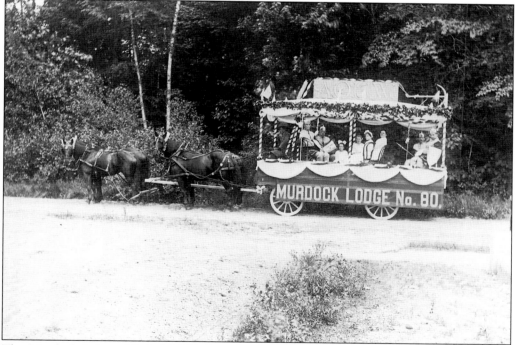

The Murdock lodge #80 A.O.U.W. float showed the officers of the organization dressed in armor, helmets, and shields.

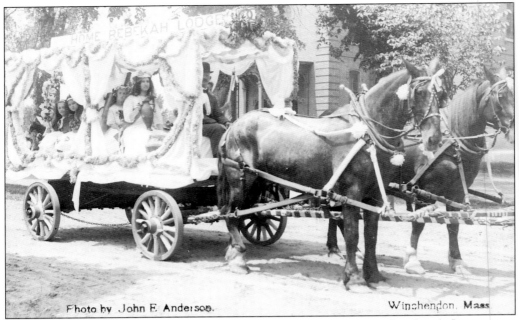

Home Rebekah Lodge's float was painted white and trimmed with laurel and pink flowers.

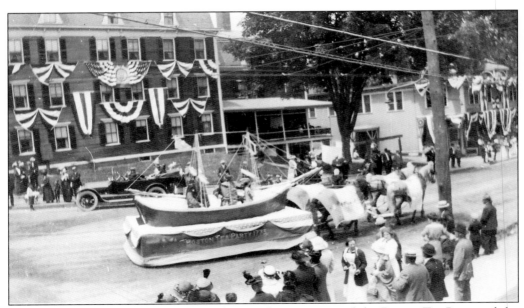

The Watatic Tribe 85, Order of the Red Men's float represented the Boston Tea Party and the ship *Dartmouth*. Some of the prominent Americans who have belonged to the Order of Red Men include George Washington, Thomas Jefferson, Paul Revere, and Franklin D. Roosevelt.

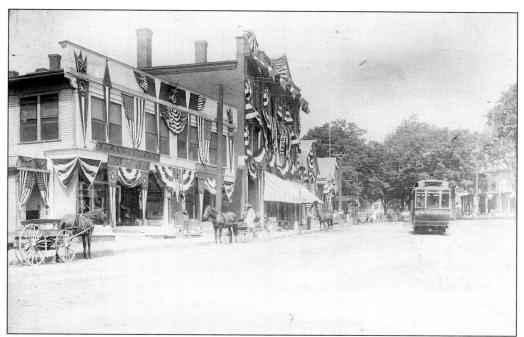

This view of Front Street shows the decorations for the 150th anniversary of Winchendon, 1914. The brick building on the left is the Murdock Building.

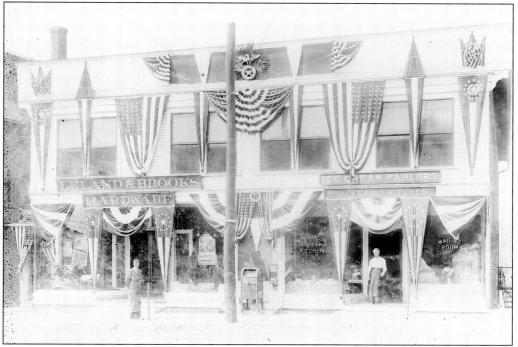

Leland and Brooks Hardware and McNay's Candy Kitchen, located at 86 and 90 Front Street, respectively, were decorated for the town's 150th anniversary. The Avon Club, one of the very earliest social organizations in the community, had their club room upstairs.

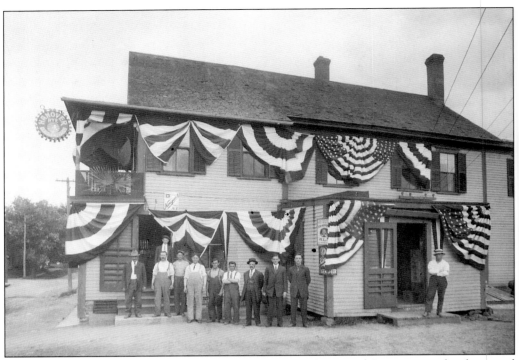

Peter Lamothe's Saloon and Sawyer's Bakery, both located on Pond Street, were also decorated for the town's anniversary.

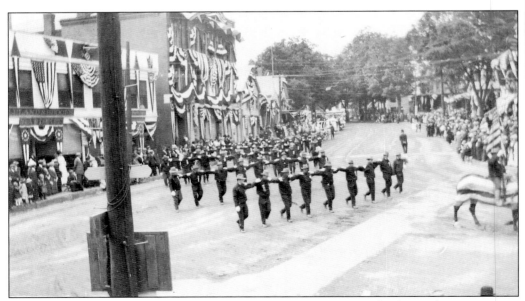

Pictured here are the Alert Veteran Foremen, also known as the Columbias. There were more than fifty men in the parade, arranged in lines of eight or nine men, with the hand-pumper Columbia behind them. They were preceded by the Columbia Drum Corps.

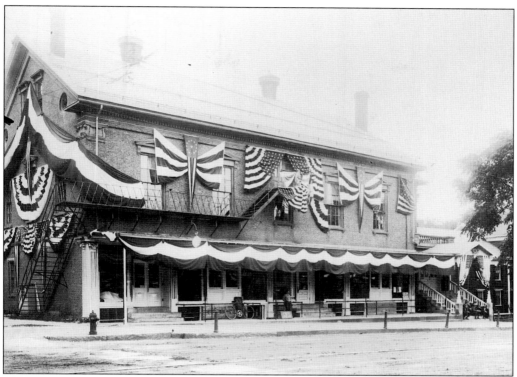

The town hall was also decorated for the 150th anniversary. In front of the building, you can see the hitching posts for the horses and the trolley tracks in the road.

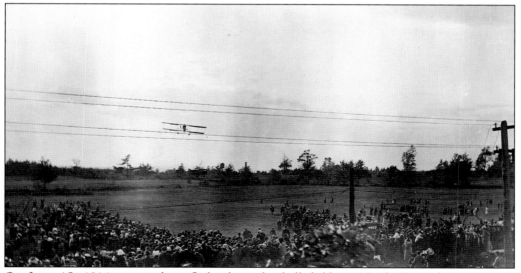

On June 15, 1914, an airplane flight from the ball field on North Central Street, with Mr. Blakely as the pilot, met with near disaster when the propeller broke and the plane crashed into the bushes. Mr. Blakely tried again on June 16, and had a successful flight.

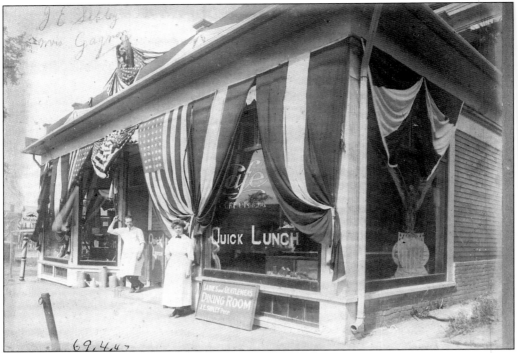

John E. Sibley's Cafe and Dining Room for ladies and gentlemen, shown here decorated for the anniversary, was located at 184 Central Street. Mr. Sibley is standing in front of the restaurant with a Mrs. Gagnon.

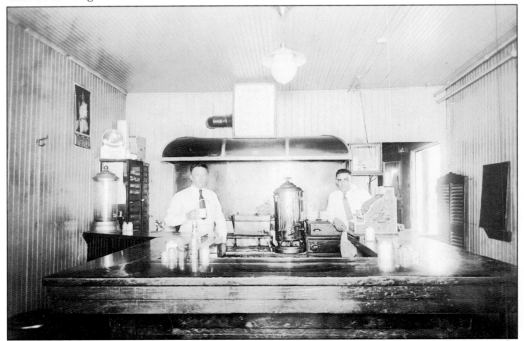

Shown here is the interior of Sibley's Cafe and Dining Room.

Two

Retailers and Shops of Winchendon

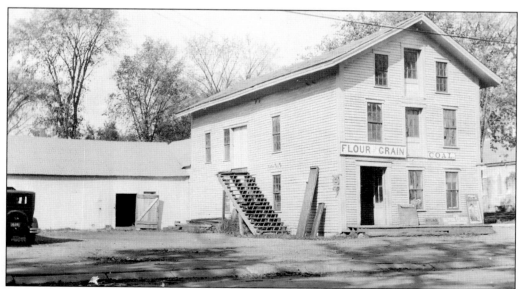

Charles E. Beals and Company was located on the corner of Central and Summer Streets, where the Athol Savings Bank now stands. Mr. Beals opened a grain store in the 1850s, and later took Wendell P. Clark into partnership with him. Mr. Beals was treasurer of the Winchendon Savings Bank and one of the founders of the First National Bank of Winchendon.

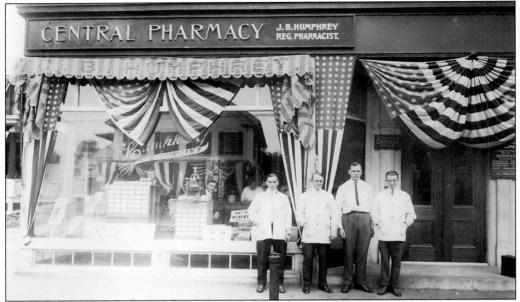

Central Pharmacy, shown here about 1914, was located on 78 Central Street and was run by James B. Humphrey. Mr. Humphrey came to Winchendon in 1909 and opened his "drug store." In 1945, Arnold E. Anderson assumed ownership of the pharmacy. This picture was taken around 1914 and the men, from left to right, are James Humphrey, Leslie Bosworth, and Lawrence Tilden. The last man remains unidentified.

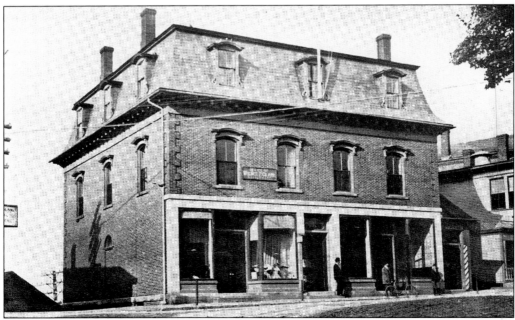

In 1867, the First National Bank and the Winchendon Savings Bank occupied its new building on Front Street. After doing business for sixty years on Front Street, the two banks voted to build a new bank jointly. About 1929 the new building, at 112–114 Central Street, was occupied by the two banks.

The first president of the First National Bank was John H. Fairbank, who served from February 27, 1864, to May 8, 1907. The early home of the First National Bank of Winchendon, which was built in 1866, is still standing at 76 Front Street.

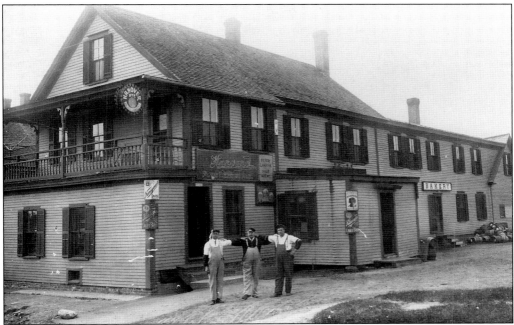

Pictured here are Peter Lamothe's Saloon and Sawyer's Bakery (which later become Lemire's Bakery). The building is located on Pond Street, and is the large building behind Belletete's store.

DURGIN'S

RELIABLE
HOUSEHOLD
REMEDIES

In placing these preparations in a new dress before my customers, friends and the general public, I wish to say that while the style of the package is new, the Remedies are old and Reliable, having been put up and sold by me during my career of over 30 years as a Prescription and Manufacturing Druggist.

cut — 66.17.1

This is an advertisement for Durgin's Pharmacy.

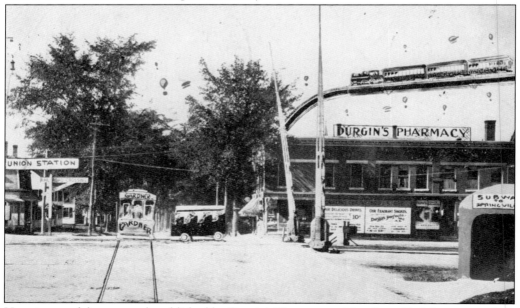

Here is one of the postcards published by Durgin's Pharmacy, with a few added features, such as the subway to Spring Village, the train going over the roof of the pharmacy, and the little bus.

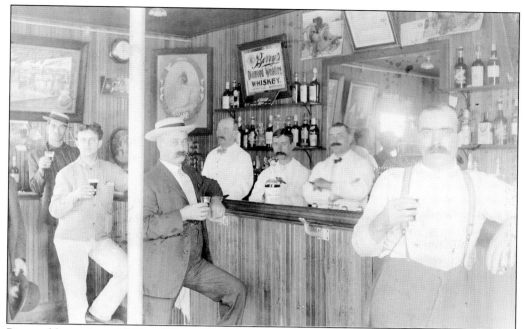

Pictured here about 1914 is the interior of Peter Lamothe's Saloon. The signs on the walls are for Schlitz Beer and Berry's Whiskey. The bottle on the bar is Bald Eagle Whiskey.

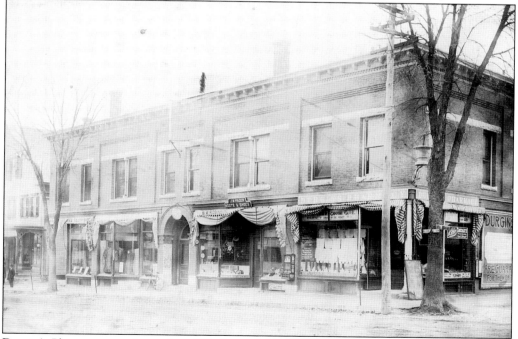

Durgin's Pharmacy was located at 220 Central Street and was owned and operated by A.G. and Fred Durgin, who started their business some time before 1890. Mary (Durgin) Loveland took over the pharmacy upon the death of her father, A.G. Durgin. Arthur J. St. Pierre and his brother Frank purchased the pharmacy in 1923, and turned it into a patent medicine store.

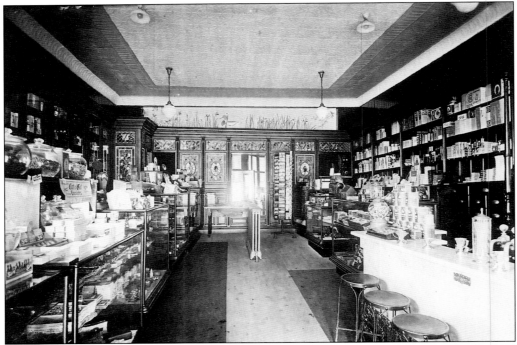

Shown here is the interior of Durgin's Pharmacy. To the right of the radiator at the back of the store there is a rack of postcards. The store also sold tobacco, candy, magazines, and had a soda fountain.

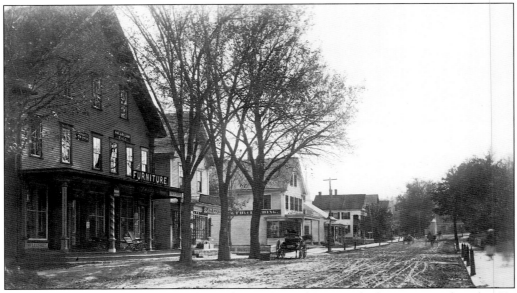

George F. Wood and Company was located at 93 Central Street, which is now a parking lot. He sold a variety of furniture, as well as toys and stoves. This picture was taken before 1906, as the Merrill Block was built in 1906.

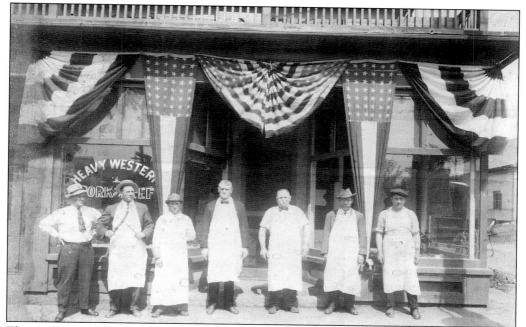

The Tucker Rice Block, shown here *c.* 1885, was located at 274 Central Street. W.D. Plummer, a druggist, had his business here, as well as George B. Raymond, a grocer; C.H. Norcross, a dentist; and N.C. Matthews, an undertaker. The building was located across the street from the CAC (Winchendon Community Action Center).

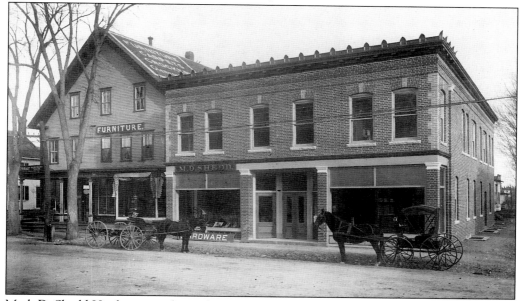

Mark D. Shedd Hardware was located at 91 Central Street and started in business about 1896. The hardware store was in the Merrill Block, where Amelia's is now located. Roland Bibeau purchased the business from Mr. Shedd in 1845 and moved it to 54 Central Street, renaming it Bibeau's Hardware Company. This picture was taken after 1906, when the Merrill Block was built, and before 1912, when the trolley tracks were first laid on Central Street.

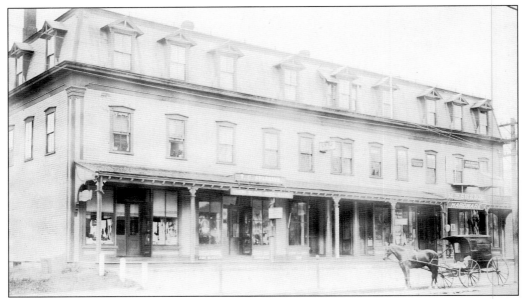

Thomas C. Sparhawk owned the Union Block Shoe Store at 92 Central Street, where the Athol Bank's parking lot is now. In 1925 the Union Block was purchased by the Independent Order of Odd Fellows, and the building later became known as the Odd Fellows Block.

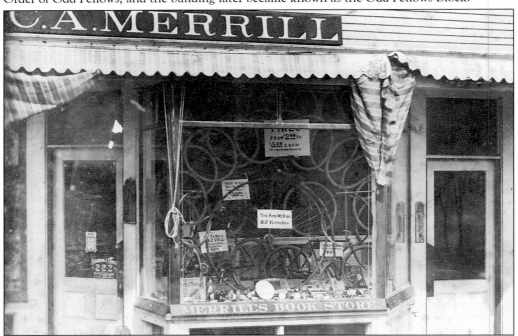

Merrill's Bookstore was located at 22 Central Street, where Joseph's Store is now located. Assuming that he sold current items, then this picture was taken around 1909, as the sign in the top left of the window is advertising the "1909 Miami" bicycle. The sign in the middle of the window says, "The Kind We Rode 25 Years Ago." The sign on the door advertises "Estabrook and Eaton's 5 cent Cigar."

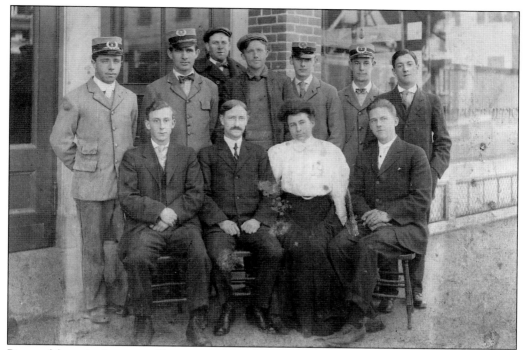

Pictured here is the post office group, Merrill's Block, about 1906. From left to right are as follows: (front row) Fred Johannesson, Postmaster Pierce, Mrs. Pierce, and Harold Whitcomb; (back row) Herbert Roebuck, Ben Tryon, John Bartlett, Cecil Bancroft, Ralph Crain, Orrie Lyon, and John Rutherford.

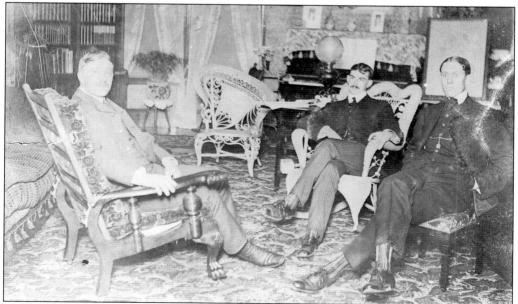

Postmaster Harry Pierce (left) is pictured here with Howard H. Eliot and Frederick Davis. Mr. Eliot and Mr. Davis were executives at the B.D. Whitney Company. The picture was taken in the parlor of the house at 57 Pleasant Street, where the Pierces made their residence.

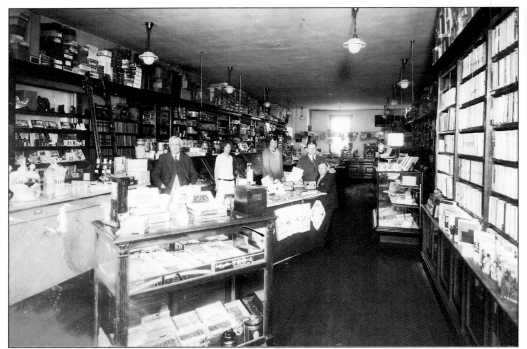

This *c.* 1930 photograph shows the Merrill's Store, at 93 Central Street. In 1923, the store was moved from 22 Central to 93 Central. Next to Merrill's Store was Woods Furniture store, where the Colonial Bank and parking lot are now located. In the store, from front to back, are Charles Merrill, Laura French, Mary Merrill, Duncan Burns, and Edwin Merrill, son of Charles.

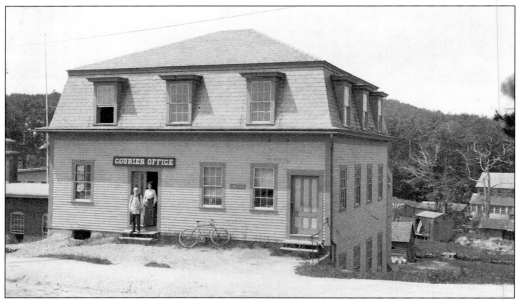

The *Winchendon Courier* was located on Front Street, near the Mason and Parker Factory. The Winchendon Cycle Club was located next door to the Courier office in the same building for a short time. After 1907 the *Courier* moved to 14 Walnut Street, in back of the Merrill Building.

After several years of publishing the *Courier*, Mr. Ward sold the paper to A.J. Nichols of Foxborough. A short time after that, the *Courier* was sold to Joseph Gorham of Barre. Etta Ward, daughter of the paper's founder, Franklin Ward, purchased the *Courier* in March 1902, and together with her father ran the paper until 1920, when the business was again sold.

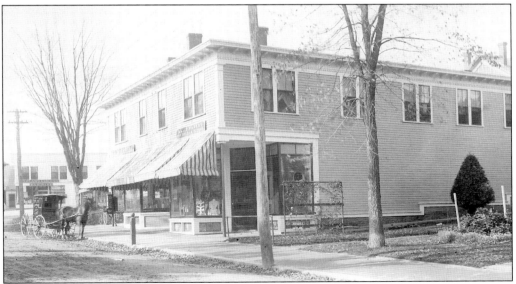

This picture was taken about 1900, with Merrill's Bookstore where Joseph's Fruit and Confectionery Store is now located at 22 Central Street. Mrs. C.J. Mayberry's Dry Goods and Cloak store is on the right. Mr. and Mrs. Joseph Solomon opened a variety store on Maple Street about 1906, which was located there until 1920. They then purchased the block at 22 Central Street and moved the business there, where the family business has been carried on ever since.

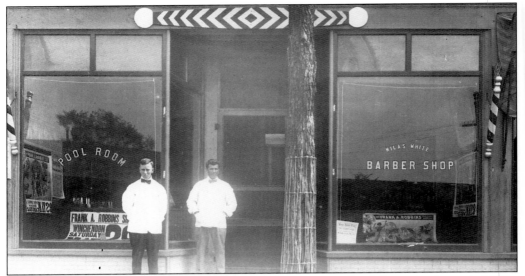

Milas White ran a combination barbershop and poolroom on Pond Street in the early 1900s. Milas is the gentleman on the right. The poster in the window reads "The Frank A. Robbins Circus Museum and Menagerie coming to Winchendon on May 29." The small white sign in the bottom right-hand corner of the barber shop window reads "Home Talent Play, The Colonel's Maid, Town Hall, Winchendon, Wednesday evening, May 26."

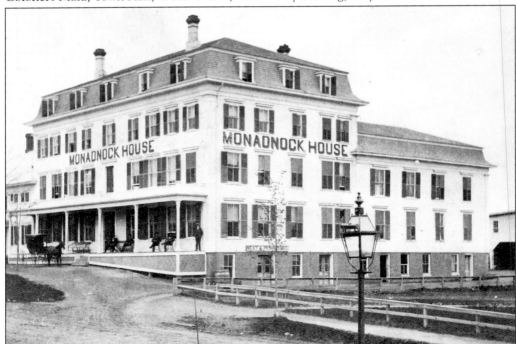

The town's largest hotel, the Monadnock House, was built in 1860, and was located where Mathieu Ford is now. The hotel later became known as the Tremont House, and still later as the Hotel Winchendon. It had sixty rooms, a dining room that seated eighty, a livery stable with thirty stalls, and it provided free carriage service between the train depot and the hotel.

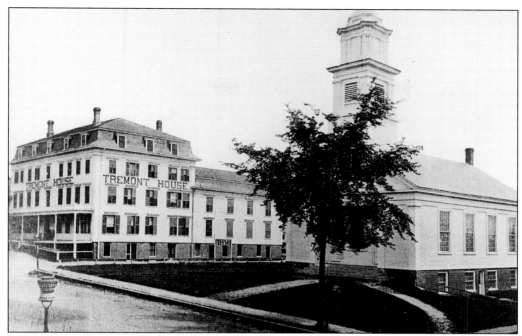

This picture of the Tremont House was taken about 1880, and shows the First Baptist Church of Winchendon, which was erected in 1848.

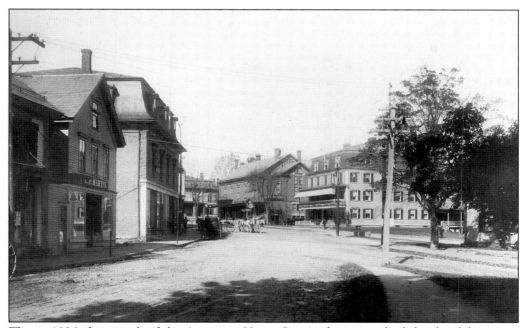

This c. 1896 photograph of the American House Square shows, on the left side of the street, Levi P. Martin's paint and wallpaper store, and the First National and Winchendon Savings Banks. On the right side are the American House and the town hall.

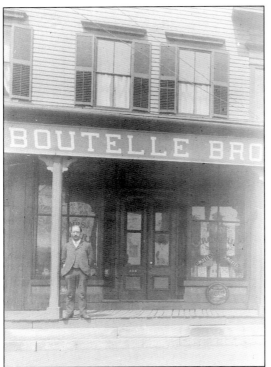

Shown here is Boutelle Brothers Grocery Store, at 206 Central Street. The store was located where Rose's Clothing and Furniture store was. Mr. Elmer Boutelle is standing on the steps.

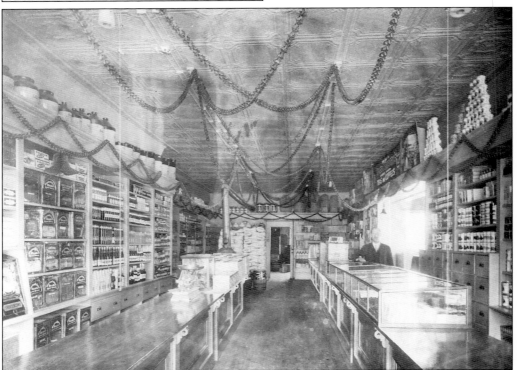

This picture, taken about 1914, shows the interior of Elmer Boutelle's grocery store.

Shown here is a c. 1900 advertisement for the New Home Sewing Machine, sold by the Wheeler Brothers, who were then located on 4 Elm Street. Ernest and Arthur Wheeler sold pianos, organs, and sewing machines, and started their business in Winchendon in 1894.

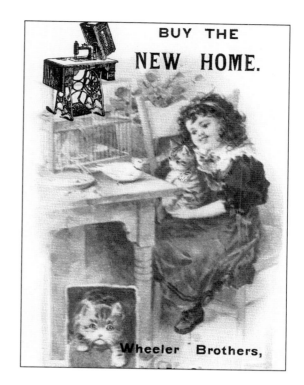

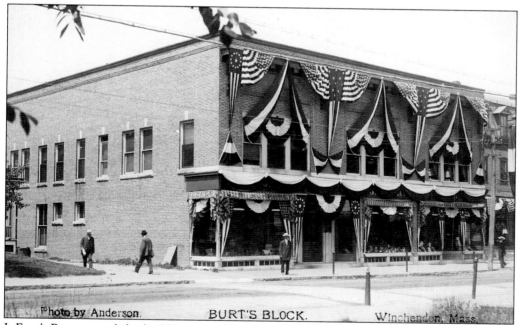

J. Frank Burt erected the building where the Winchendon District Court is now located. The building cost about $25,000 in 1908 and was sold to the Artisan Building Incorporated in 1919. Today it is called the Artisan Building.

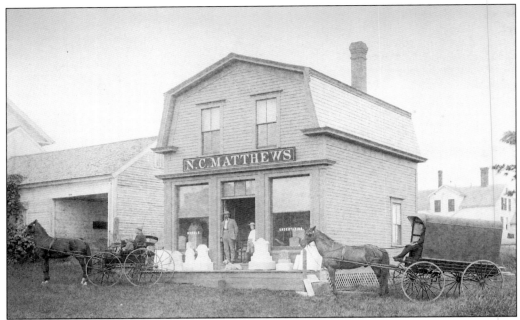

The granite works of N.C. Matthews are shown here, c. 1900. Matthews made and sold granite and marble monuments, and also did undertaking. The stone work, including the legend "I.M. Murdock Block," was done by N.C. Matthews for the Murdock Building on Front Street.

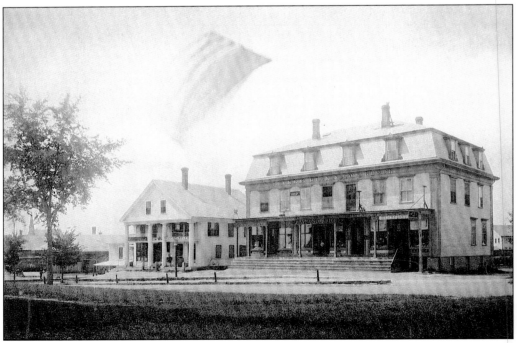

The Tucker Rice Block, shown here c. 1885, was located on Central Street and housed W.D. Plummer, a druggist; George B. Raymond, a grocer; C.H. Norcross, a dentist; and N.C. Matthews, an undertaker.

Three

The Manufacturing Families of Winchendon

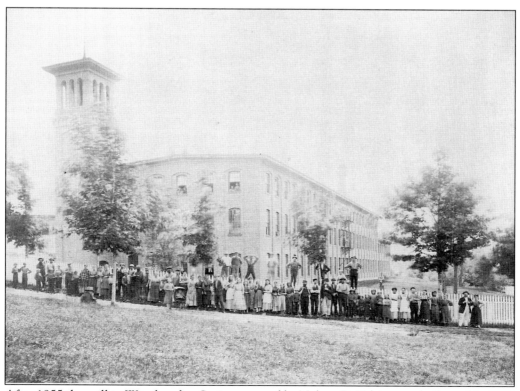

After 1855 the mill in Winchendon Springs, owned by Nelson D. White, was built, and in 1868 additions were made. The mill was purchased by Ray Plastics in 1960 and is still in use today.

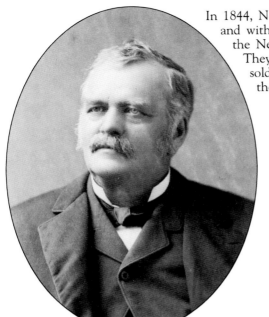

In 1844, Nelson Davis White came to Winchendon, and with his father, Joseph White, he established the Nelson Mills in the Springs and Glenallen. They manufactured colored cotton goods and sold their products throughout the country and the world.

The White family is shown here in this photograph taken sometime before 1912, at their house at Mill Circle. The house was later torn down. From left to right are Aman Temple White, Zadioc Long White, Mellie White, Percival Wayland White, Julia White, Joseph Nelson White, and Charles White. Percival Wayland White, son of Nelson D. White, was lost on the *Titanic* with his son Richard on April 19, 1912.

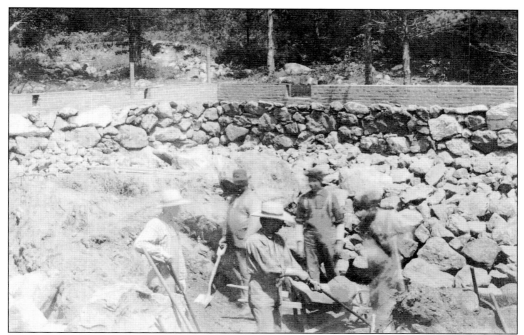

It would appear that a lot of the work for the cellar hole for Marchmont was done by hand.

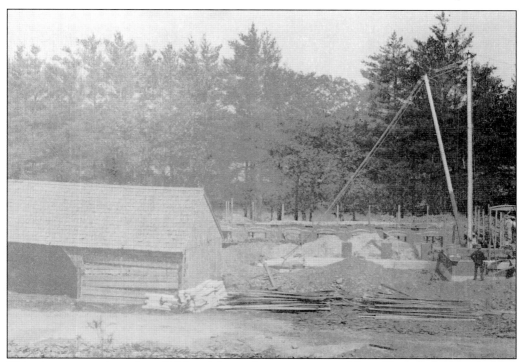

This picture was taken about 1887 and shows the construction of the cellar hole for Marchmont. The building on the right was probably made into the garage and would be located in the back of the house.

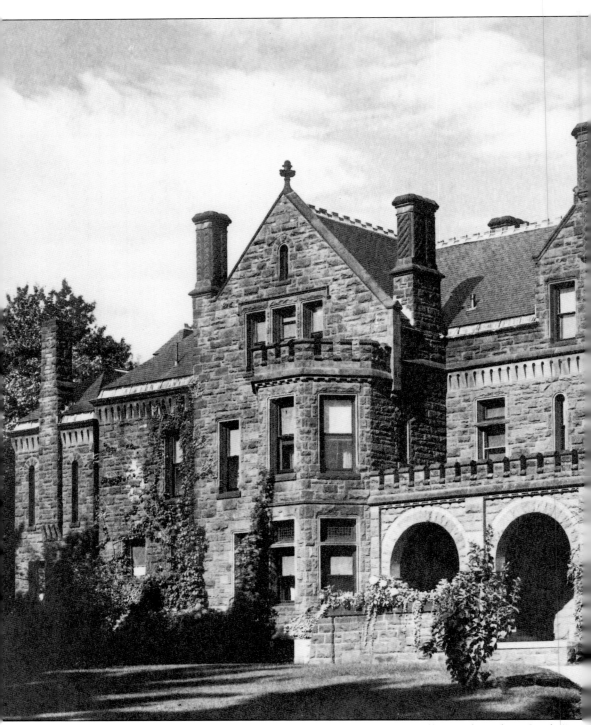

Marchmont was located in Winchendon Springs and was known locally as "The White Castle." It was built by Joseph Nelson White, and took several years to build. In 1890, Mr. White and his family moved into Marchmont.

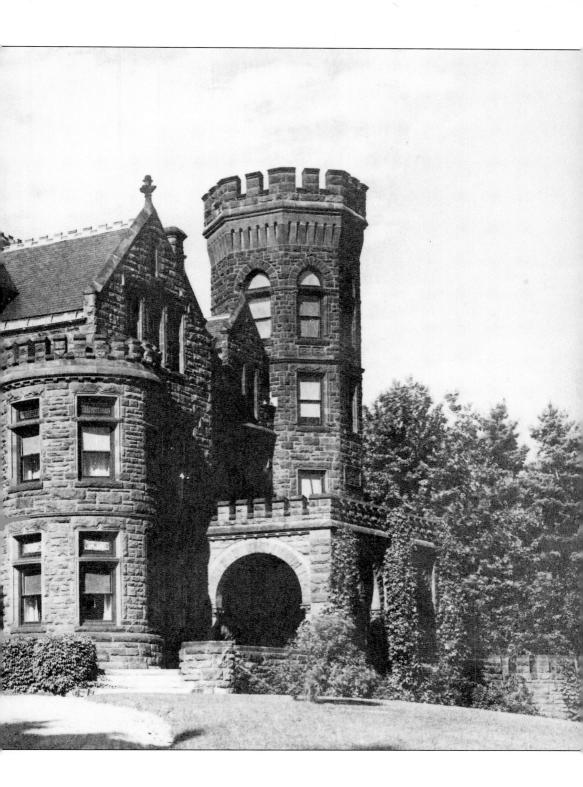

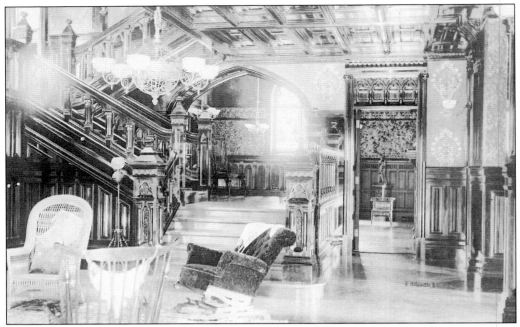

The reception hall at Marchmont. The castle had more than twenty rooms and was considered one of the most beautiful homes in Winchendon. Marchmont has since been torn down, and all that remains is part of the foundation.

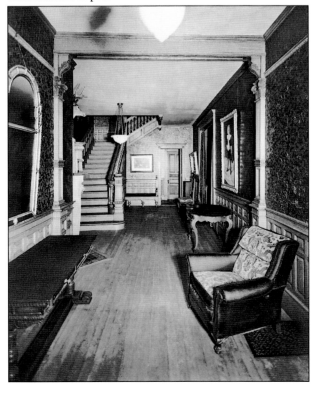

This is another view of the interior of Marchmont. Every room was beautifully decorated.

An advertisement offering for sale "Marchmont," in Winchendon Springs, Massachusetts, for a mere $37,500.

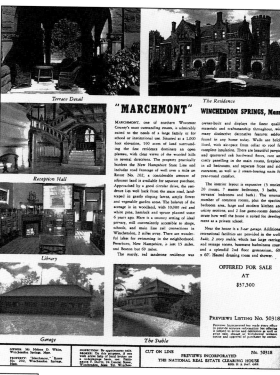

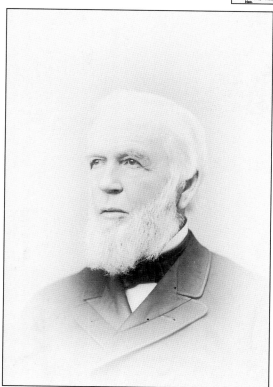

Baxter Dodridge Whitney was a man of extraordinary mechanical ability. In 1845, he established a machine shop and foundry, and built a dam for water power. The shop and foundry were located on the site now occupied by the Goodspeed Machine Company and Playaway Lanes.

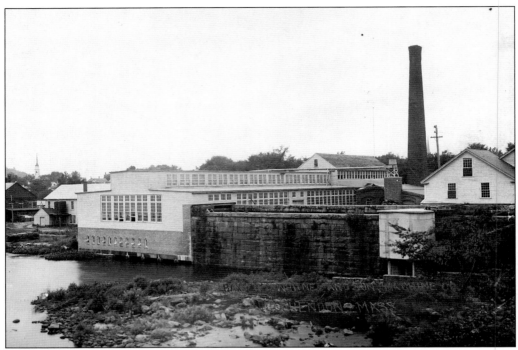

This photograph of the Millers River shows the back of the Baxter D. Whitney machine shop. The granite wall is part of a sluiceway that carried water from the dam a few hundred feet up the river to a water wheel that produced power for the shop. The foundation of the main part of the shop near the river is on granite blocks and runs the entire length of the building. There is a tunnel that runs under the building about 4 feet by 8 feet, with smaller passageways running to the left. There are at least two smaller rock-lined drains, about 3 feet by 3 feet, that run left and right below the main passageway floor. The heat for the plant was produced by a large boiler, which can be seen at the base of the tall chimney.

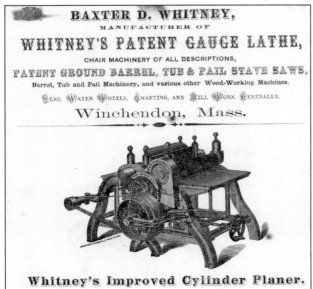

Whitney's Improved Cylinder Planer.

Baxter Whitney made wood-working machinery, such as the Cylinder Planer, for planing wet or pitchy lumber, and the Gauge Lathe, for turning beaded and nulled work for chairs and bedsteads.

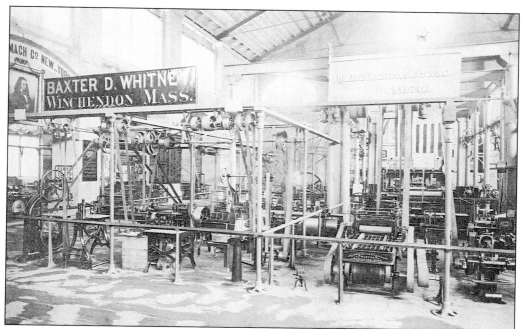

Medals of bronze, silver, and gold were awarded wherever Mr. Whitney's machines were shown, such as the World Exposition in 1873 in Vienna, Austria, as well as other expositions in Paris and Philadelphia.

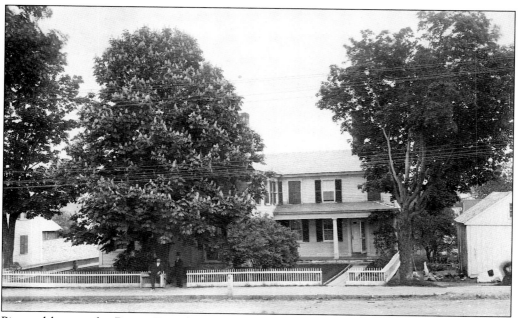

Pictured here is the Baxter D. Whitney house, located on the corner of Central and Spring Streets. Mr. Whitney is the gentleman standing in front of the house.

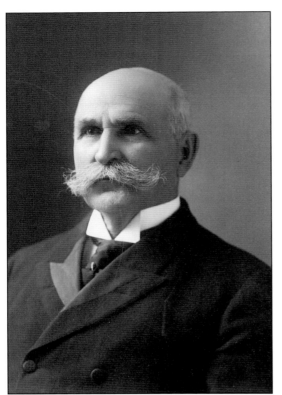

In 1878 Morton E. Converse came to Winchendon from Rindge, New Hampshire, and started his toy and woodenware business in Waterville with Orlando Mason. In 1883 the partnership was mutually dissolved, and Morton Converse went into business with his uncle, Alfred E. Converse, and changed the name of the company to Morton E. Converse and Company. The company was now located off of Jackson and Franklin Avenue, and was called "America's first and largest toy factory." At one time it employed about 1,000 workers.

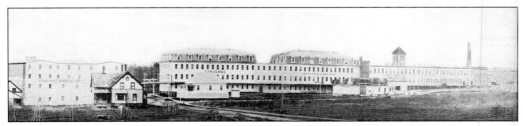

The Converse Factories occupied over 6 acres of land, and in 1904 employed about three hundred people.

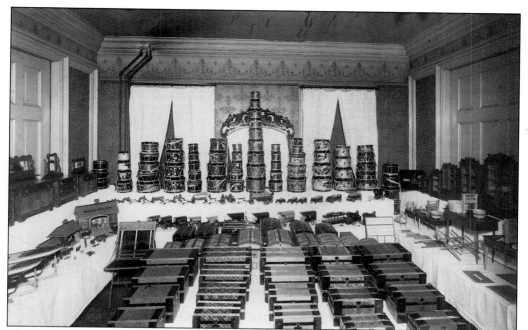

This photograph of an exhibit of Converse toys was taken about 1900. Over 1,500 drums were manufactured each day, with sixty different styles being offered. Converse also manufactured hobbyhorses and rocking horses, cast-iron toys, doll furniture, and other wooden novelties.

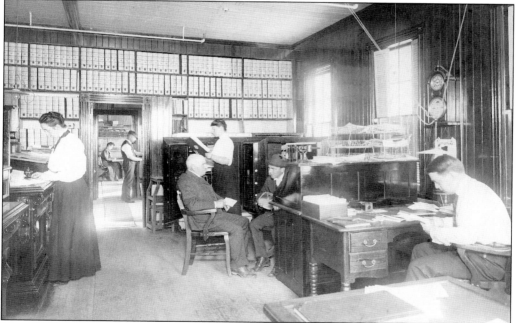

The office staff of Morton E. Converse are shown in this photograph taken in the early 1900s. From left to right are Miss Peak, Miss Cora Wheeler, Arthur Roebuck, Miss Katherine Allen, Morton E. Converse, Atherton D. Converse, and William Hazlitt, who later become president and general manager.

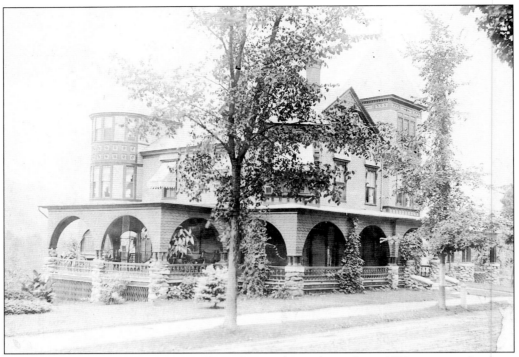

The Morton Converse mansion on Front Street, shown here about 1900, contained a large reception hall, bowling alley, ballroom, and conservatory. In the rear of the house were very lovely gardens, which were the scene of many parties. The mansion was taken down in the 1920s.

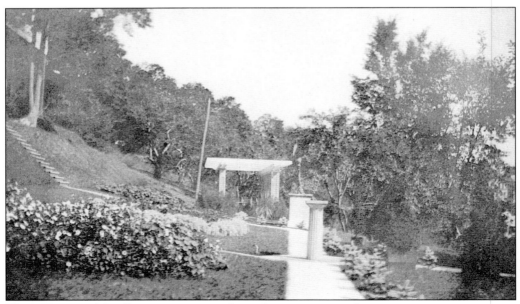

This rear view of the Converse mansion shows the extensive gardens.

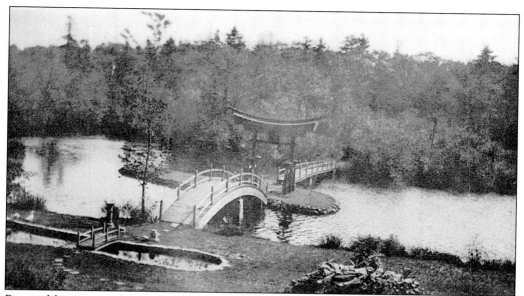

Pictured here is another view of the Converse Gardens, showing the bridge going across the Miller's River.

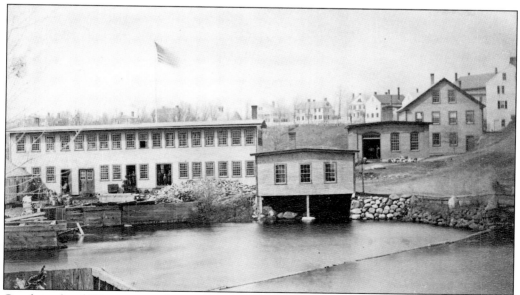

Goodspeed and Wyman manufactured butter churns and sewing machines. They also made spool and bobbin machines and machinery for chair manufacturing. The company was established in 1860 by G.W. Goodspeed and Harvey Wyman. In 1898, after the death of Mr. Wyman in 1879 and the death of Mr. Goodspeed several years later, the company was purchased by some of the employees and renamed the Goodspeed Machine Company.

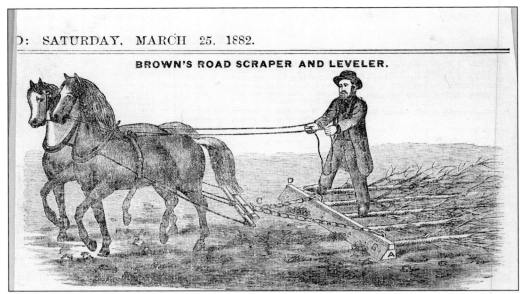

BROWN'S ROAD SCRAPER AND LEVELER.

In 1882, William Brown II was manufacturing a road scraper at his company, the Winchendon Road Scraper Company. One of the numerous testimonials of the merits of the road scraper was given by E. Murdock Jr. "Mr. Brown. Dear Sir: After watching the results of the working of your Road Scraper and Leveller on the roads in this town for the past year, I think I am warranted in saying it is a great improvement in repairing roads. I am of the opinion that by the use of your scraper in the town the past year we have saved one fourth of the former expense of repairing our roads, and have had much smoother and leveler roads than ever before."

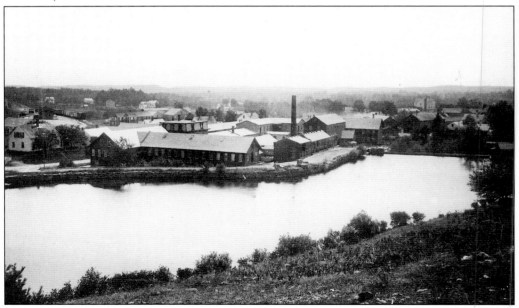

In the early 1800s, Elisha Murdock began the manufacture of wooden pails with the machinery that his brother, the late Colonel Murdock, had made for him. William Webster Whitney, Elisha Murdock's son-in-law, joined the business in 1859. This picture shows the factory in Waterville in 1885.

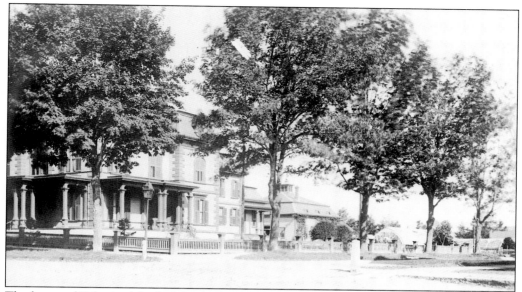

The home of Ephraim Murdock Jr., built around 1850, was located at the corner of Front and Pleasant Street, and is now the location of the American Legion Park and Monument. Ephraim Murdock Jr. died in 1882, and left his house to the Unitarian Church as a parsonage.

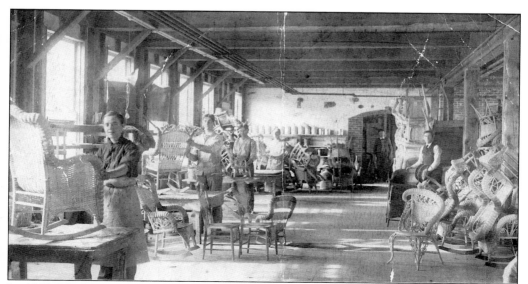

In 1892 Mr. M.L. Bartlett started a company known as M.L. Bartlett and Company. The company made high-grade reed furniture. A year later, Mr. Bartlett died and Mr. C.L. Carter and Mr. Christopher J. Campbell took over the business and changed the name to Carter and Campbell Company.

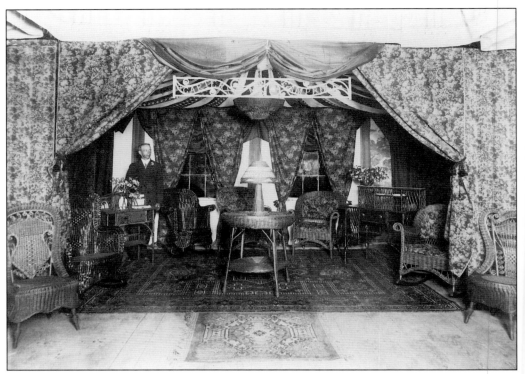

This is an example of the reed furniture made by Carter and Campbell Company. This must have been an exhibition of some sort; note the name of the company at the top center of the picture.

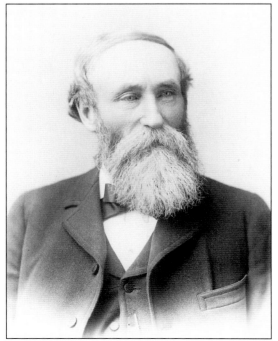

After an apprenticeship in the mills of E. Murdock Jr., Wilder Philander Clark went into business for himself. He purchased the Murdock and Fairbanks mills at Glenallen in 1883, and in 1890 purchased the Woodcock Mills at Waterville. He manufactured almost everything in the line of woodenware, such as wooden tubs, pails, washboards, and buckets.

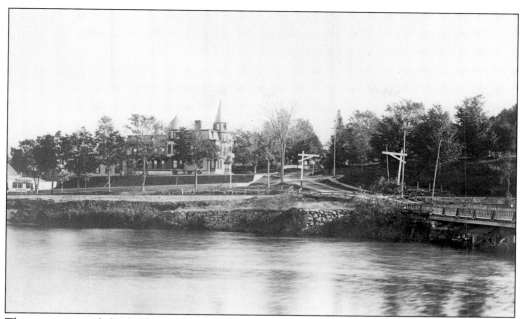

This is a view of the bridge leading up High Street, with the Wilder P. Clark Mansion on the left and Goodspeeds Pond in the foreground. The house was built in the early 1880s, and Mr. Clark called it "Mapleview."

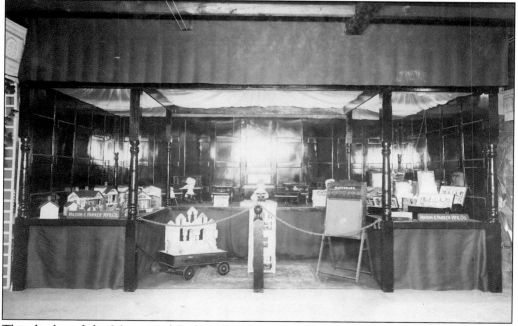

This display of the Mason and Parker Manufacturing Company, *c.* 1900, shows doll houses, pianos, chalkboards, and games such as ring toss and tenpins. Late in 1913, Mason and Parker acquired the toy business of a Rhode Island company, the R. Bliss Manufacturing Company of Pawtucket.

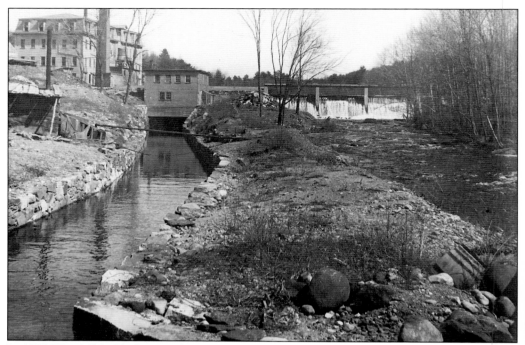

In 1872 Wendell P. Clark opened a mill in Centerville for the manufacture of chairs. Centerville lies on River Street, between the base of Tannery Hill and the George M. Whitney Memorial Bridge. His business prospered and enable him to provide the town with the Wendell P. Clark Memorial Recreation Building.

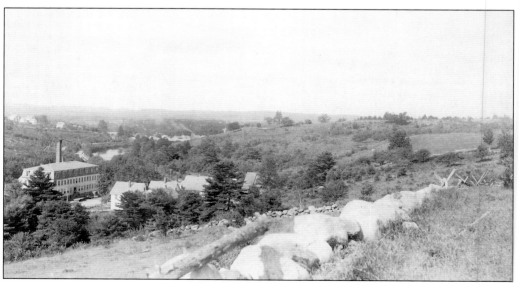

This is a view looking down on the Wendell P. Clark chair factory, as well as houses along River Street in Centerville.

Mr. Orlando Mason operated a mill in Waterville, c. 1870, and manufactured three hooped and enameled cedar and pine pails, different wooden boxes, and churns. He employed between fifty and sixty men.

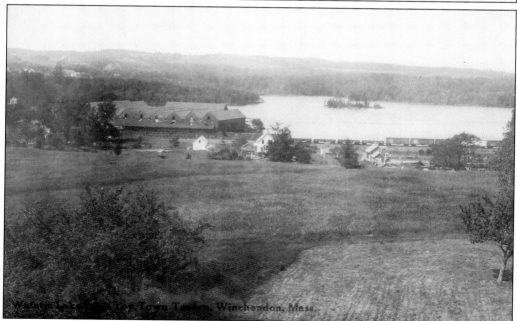

This is a view of Whitney's Pond from the Toy Town Tavern, c. 1930. The large warehouses on the left next to the pond were icehouses owned by the New Bedford Ice Company. The ice was loaded on the train cars and shipped daily to Worcester and other places.

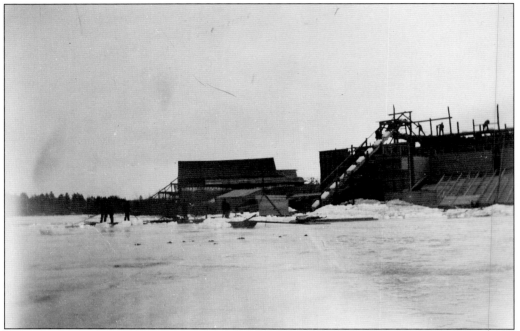

J.H. Davenport and Son was originally a hay and coal dealer, and had been in business since 1870. In 1927, Ray Bartlett assumed ownership of the company and expanded the business to include coal, fuel oils, ranges, and ice. You can see the blocks of ice going up the conveyor belt, where they were stacked and packed in sawdust for insulation.

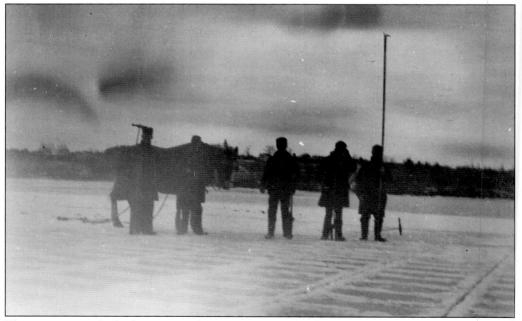

The ice was marked, then cut with an ice saw, and taken to the icehouse by horses. J.H. Davenport and Son's ice house, located on Whitney's Pond, provided ice for the railroad for a number of years.

John Folsom, who was the first town tree warden, was also an inventor and manufacturer of the Folsom Sewing machine. The sewing machines were sold in the United States and abroad.

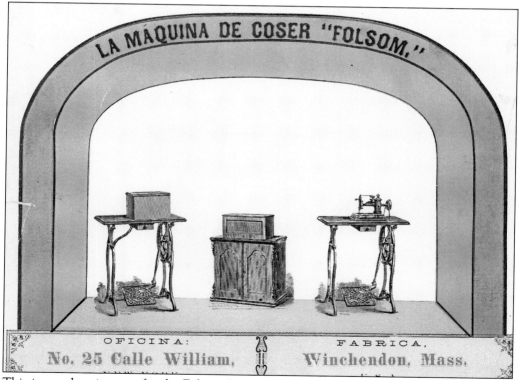

This is an advertisement for the Folsom Sewing Machine, c. 1890. In 1968 a Folsom Sewing machine was unearthed in the city of Walsall in Staffordshire County, England. The inscription on the machine read "Made in Winchendon, Mass. Patent Pending May 17, 1864. J.G. Folsom—maker."

This view of Central Street was taken before 1912, as there are no trolley tracks. The Folsom House on the right is where the present post office is now located. Showing through the trees to the right is the steeple of the Unitarian church, and on the left is where the Clark Memorial is now located.

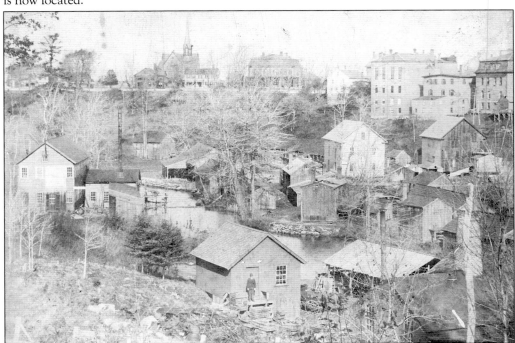

Pictured here is Miller's River, below Prospect Street off Front Street and High Street. D.H. Piper, for whom Piper's Grove was named, manufactured axes, sewing machine shuttles, and light machinery. Hill and Bosley, an iron and brass foundry, is visible in the lower right-hand corner of the picture; D.H. Piper's manufacturing facility is the building farthest to the left.

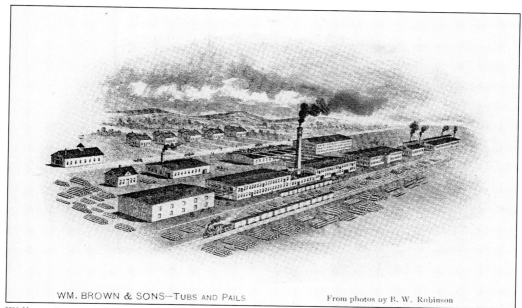

WM. BROWN & SONS—TUBS AND PAILS From photos by B. W. Robinson

William Brown and Sons was a manufacturer of wooden tubs, pails, and packages for candy, lard, jelly, and fish. The mill was established in 1878 at Bullardville by William Brown. His sons, Arthur and William, came into complete control of the business upon the death of their father in 1888.

The New England Lock and Hinge Company, *c.* 1910, was located at 30 River Street, and manufactured steel toys and light hardware. One of their products was a steel toy sailboat.

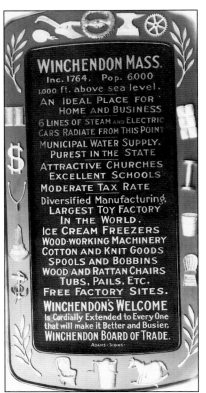

The Winchendon Board of Trade, instituted February 19, 1909, was one of the largest organizations in town. Its primary objective was to promote the town and unite the business and social relations of the members.

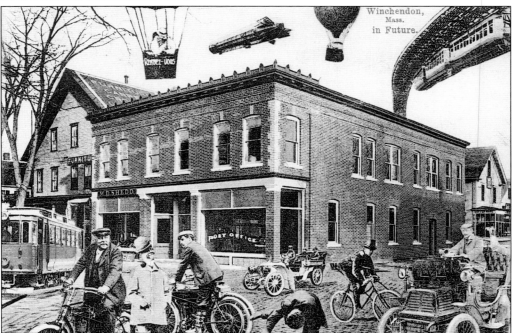

Winchendon in the future, showing Central Street, with the Merrill Block located on the corner of Central Street and Walnut.

Four

Educational Institutions and Houses of Worship

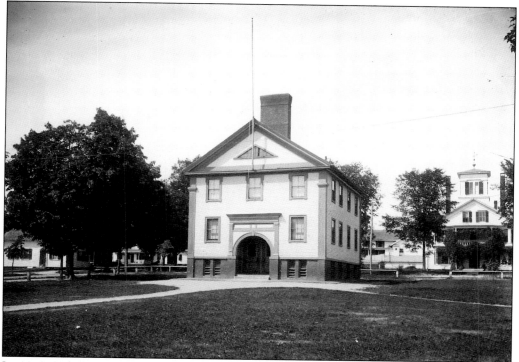

In 1843, Ephraim Murdock erected a building at the junction of Front and School Streets, which was called the Winchendon Academy. This school was to provide for more advanced studies than could be obtained in the district schools. The building, most recently used for the Veterans of Foreign Wars, was sold and torn down in 1996.

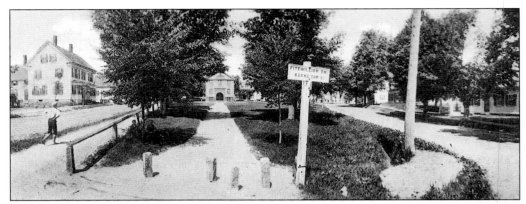

This postcard of the Winchendon Academy was taken in the early 1900s. The building was willed to the town of Winchendon when Mr. Murdock died, with the provision that it be used for educational purposes.

Shown in this 1867 photograph is the Rev. Joseph Fielden, who was principal of the old Winchendon Academy. He was also pastor of the First Baptist Church in Winchendon for nearly sixteen years, from 1896 to 1912.

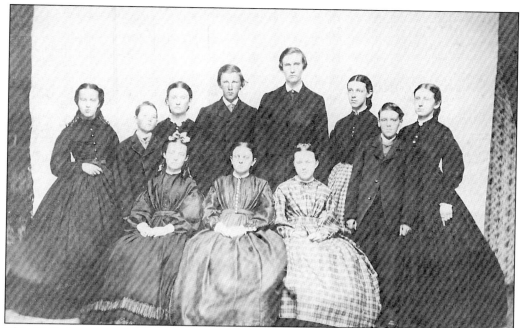

This 1865 photograph shows a Latin class in the old Academy, located in School Square. From left to right are as follows: (front row) Eva Hastings, Emma Parks, Mary Chamberlin, and Charles Brown; (back row) Nettie Murdoch, Dwight Mason, Bessie Poland, George Beaman, John Hale, Mary Clark, and Mary Marvin.

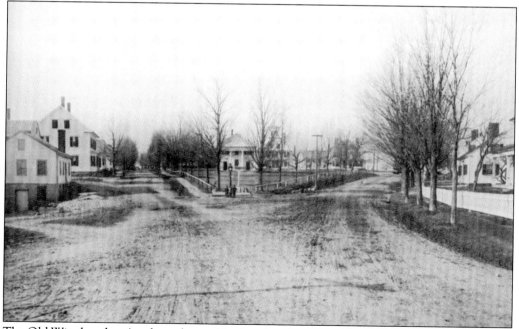

The Old Winchendon Academy, located in the triangle of School and Front Streets, was erected in 1843 by Ephraim Murdock. Shown in this c. 1885 photograph, it still has its stately white pillars. The pillars were removed about 1894, when the building was remodeled.

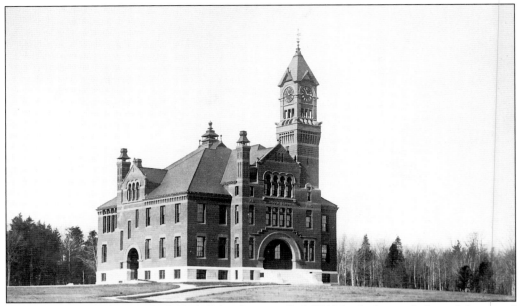

On June 21, 1887, the Murdock High School, now called Old Murdock, was dedicated. It opened for use on August 31, 1887, and was considered one of the finest high schools in Massachusetts.

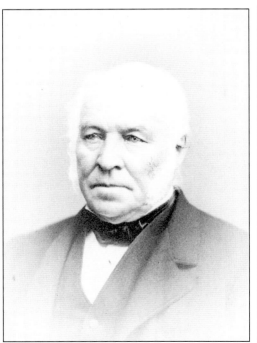
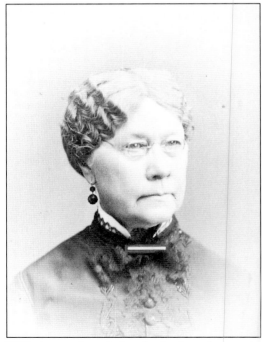

Upon the death of Ephraim Murdock Jr. in 1882, it was found that he had made certain provisions in his will for money for a new high school. The building he had provided for was begun in 1884. Shown in the photograph on the right is Mrs. Ephraim Murdock Jr. (Sophia Ayer Morse), who was born in 1805 and died in 1888.

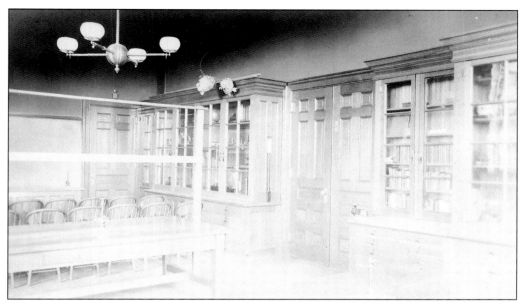

The science and physics lab on the second floor of Murdock High School is pictured here, c. 1910. The building was heated by steam and had gas lights. There were also laboratories, an art studio, a library, several offices, and an assembly hall.

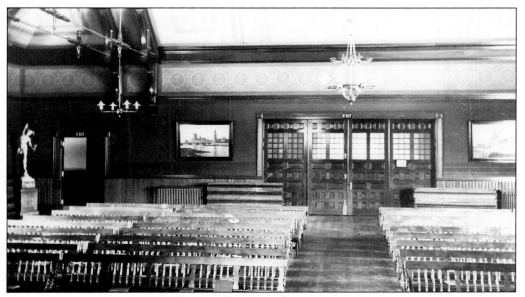

The auditorium at Murdock High School is shown here.

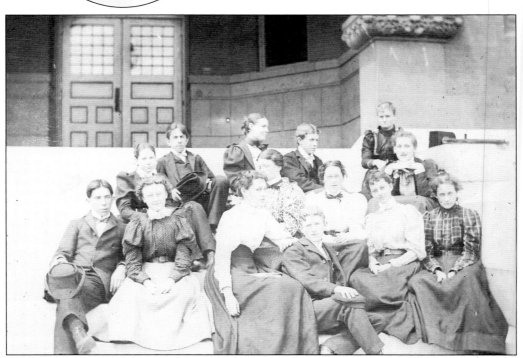

Frank Collester became the principal of the New Murdock School (old Murdock High School) when it opened on August 31, 1887. Mr. Collester was a teacher at the Brick School, which was the first "town-built" high school and which later became known as the Wheeler School, in honor of Reverend Charles Wheeler, who served on the school committee for several years.

This photograph shows the Class of 1898 at Murdock High School (Old Murdock). From left to right are as follows: (front row) Ernest Jones, Calista Norcross, Alice Brown, Walter Wellman, Bertha Pierce, and Bertha Goddard; (middle row) Nellie Appleton, Effie Gross, Edith Sawyer, and Katherine Gorham; (back row) Richard Farrell, Josephine Tubbs, Cecil Annett, and Myra Boyce.

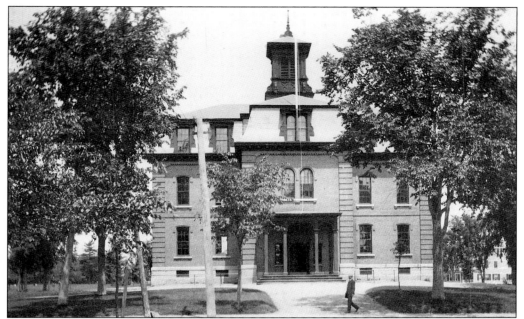

In 1867 the first "town-built" High School was built on Oak Street, and was called the Winchendon High School. It was used as the high school until Old Murdock was completed in the later 1880s, and was later called the Wheeler School.

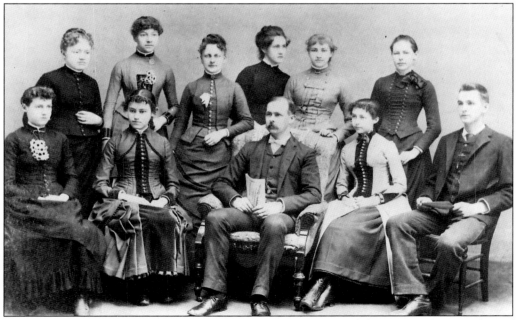

The last class of Winchendon High School on Oak Street, and the first graduating class of the Murdock School (Old Murdock High School) at the corner of Grove Street and Poland Avenue. From left to right are as follows: (front row) Mae Wells, Label Ballou, principal Frank M. Collester, Mattie Barnes, and Andrew Adams; (back row) Sarah McCrae, Edith DeMary, assistant principal Clara M. Whitney, Josephine Gay, Fanny Kemp, and Eva Deland.

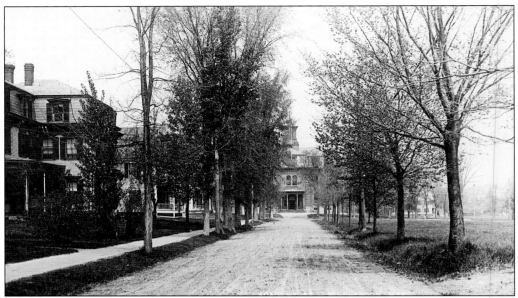

This is a view of Academy Street looking toward the Wheeler School on Oak Street. The Wheeler School was also called the Brick School and the first Town-Built High School. The Wheeler School was torn down in the summer of 1965.

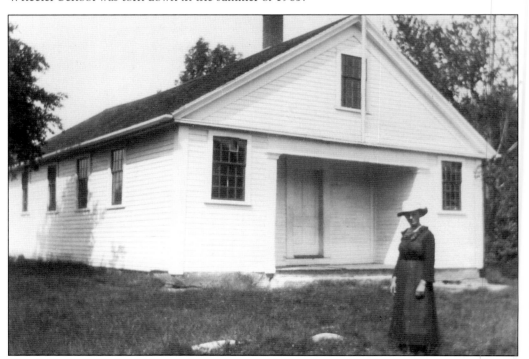

The Bullardville School House, shown here c. 1850, is located in the northwest part of town in the vicinity of Royalston Road North. The lady in the picture is Rosina (Rose) May Combo (Campbell). Charles Bullard owned a mill site and lived here in the early 1800s, and it is probably from his name that we got Bullardville.

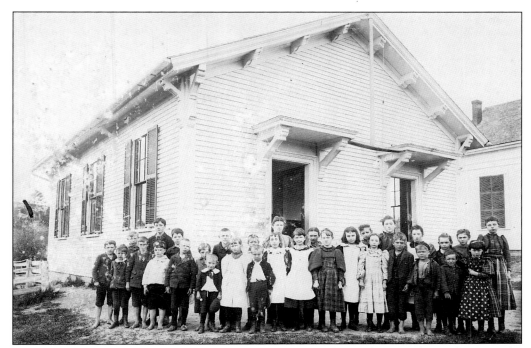

This photograph from the late 1890s shows the Rice School in Old Center, located next to the First Congregational Church. Genevieve Sykes, the teacher, is in the center of the students in the back row. It must have been a nice warm day, as most of the boys are barefoot.

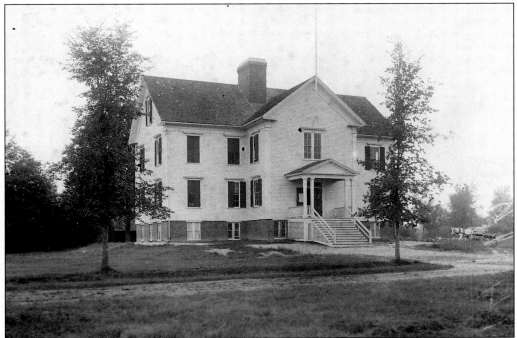

The town voted to build a schoolhouse in Waterville in 1869. The building became known as the Woodcock School. Four years later, additional classrooms were added on the second floor.

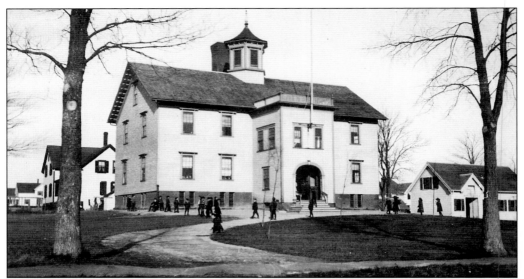

The Tucker School was built in the late 1800s. At that time it was called the North School, and was located where the fire station is now located. In the early 1900s the school was remodeled, the foundation was raised, and new heating and ventilation systems were installed. In 1904 the school was renamed the Tucker School, honoring the settlers of that neighborhood.

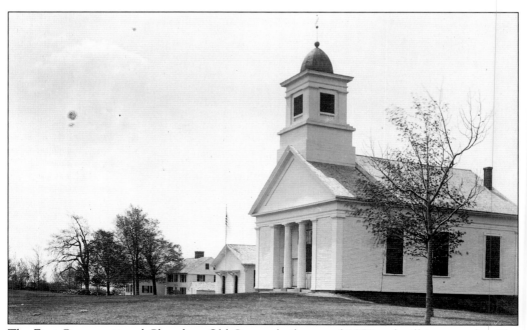

The First Congregational Church at Old Center, built around 1850 and still in use today. The Rice School on the left was built around 1873, and was used for the sixth grade at that time. It was taken down in 1937.

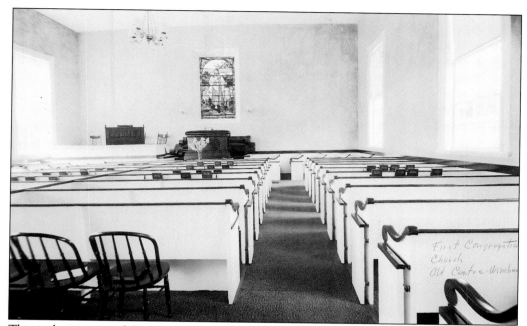

This is the interior of the First Congregational Church in Old Center as it appears today. The church had a beautiful communion service which was used at the first meetinghouse and can be seen today at the Winchendon Historical Society.

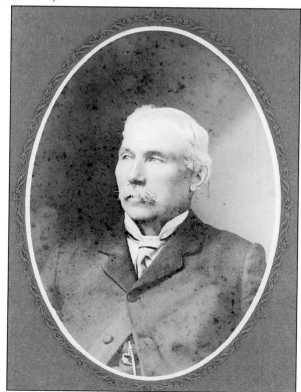

Shown here is the Reverend Gustavus W. Jones, the pastor who served the First Congregational Church at Old Center from 1890 to 1928.

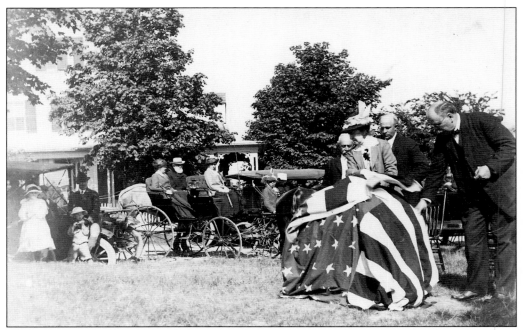

This photograph shows the dedication of the stone commemorating the first church in Winchendon, organized in 1762. The stone stands at the southeast corner of the Common at Old Center and was dedicated in 1914. Dedicating the monument are, from left to right, Dr. Alfred Free, Miss Mary Marvin, Reverend Eames of Athol, and Mr. Bangs of the Baptist Church. In the carriage in the center of the picture is Baxter D. Whitney.

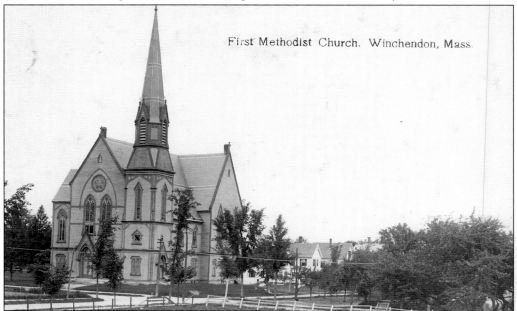

First Methodist Church. Winchendon, Mass.

The Methodist church was dedicated on September 9, 1875, and was located on the corner of Oak Street and Lincoln Avenue. At the time of its dedication, the church had a congregation of about 400, with the Reverend W.M. Ayres as pastor.

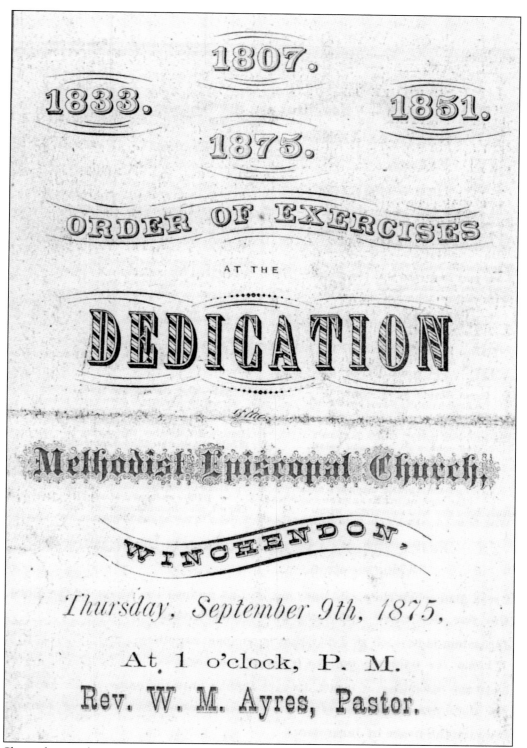

1807.

1833. **1851.**

1875.

ORDER OF EXERCISES

AT THE

DEDICATION

of the

Methodist Episcopal Church,

WINCHENDON,

Thursday, September 9th, 1875.

At 1 o'clock, P. M.

Rev. W. M. Ayres, Pastor.

Shown here is the Order of Exercises for the dedication of the Methodist church in 1875.

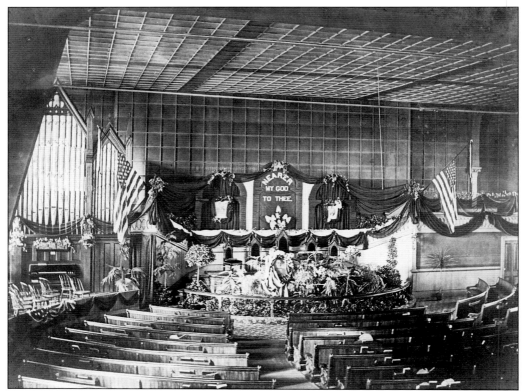

The Methodist church was decorated for President William McKinley's funeral on September 19, 1901. McKinley was shot twice by an assassin at the Pan American Exposition in Buffalo, New York, and died on September 14, 1901.

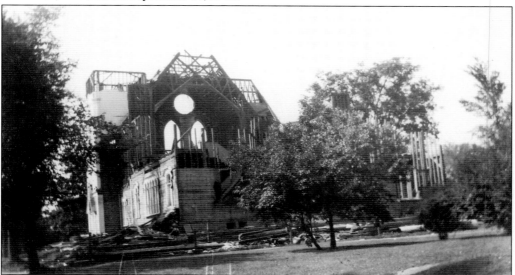

In 1940 the membership in the Methodist church had declined and it was decided that it was impractical to keep up a church so much larger than what was needed. In 1947, the church was destroyed.

The second Methodist church, located on what is now School Square, was dedicated on October 11, 1833. By 1851 the congregation had increased to over 200, so the church was enlarged and a steeple added. School Square is located at the beginning of School and West Street.

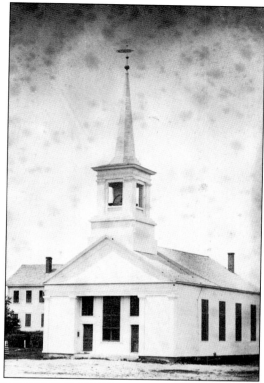

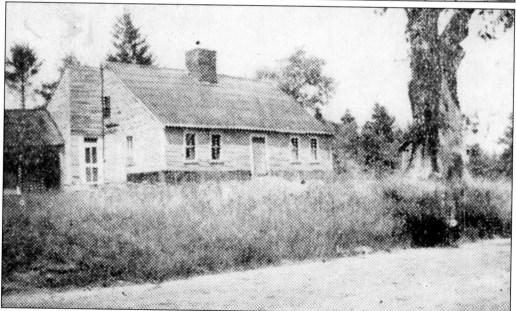

Lorenzo Down, a Methodist circuit rider, preached in this house on October 25, 1796. It was the first Methodist sermon preached in Winchendon. The house was then occupied by Eber Arnold, and was located on River Street. In the late 1950s a marker was dedicated to mark the spot.

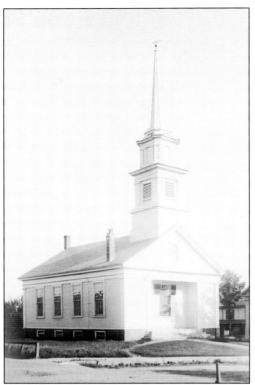

The First Baptist Church on Central Street lost its steeple and clock in the hurricane of 1938. Up until 1896 the church had been called the Winchendon Village Baptist Church. At that time, the name was officially changed to the First Baptist Church of Winchendon.

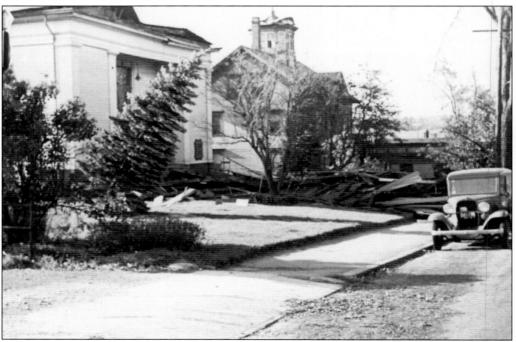

When the hurricane of 1938 was over, damage to the town was set at $1,500. The First Baptist Church was badly damaged with the loss of its steeple.

The Church of the Unity, located on the corner of Central and Summer Streets, was dedicated in November of 1867. The cost of the church was about $44,000. It was built upon the insistence of the Reverend Charles H. Wheeler for a suitable house of worship. Work was begun in April 1866. The church is built of Fitzwilliam granite, and its steeple rises 113 feet from the ground.

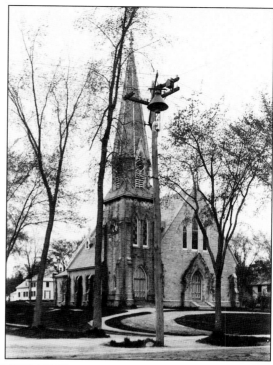

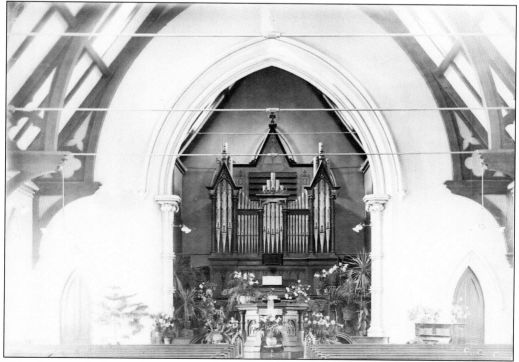

This photograph shows the interior of the Church of the Unity. There are ten stained-glass memorial windows in the church.

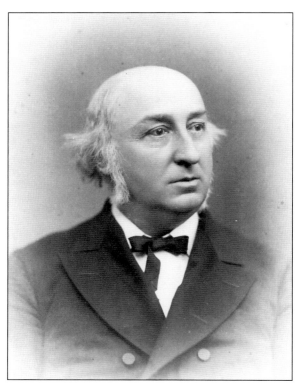

In 1865 the Church of the Unity secured Reverend Charles Henry Wheeler as the residing minister. He was the minister of the church from 1865 until his death in 1888. The Reverend and Mrs. Wheeler were riding in their carriage and were struck by a train and killed at the State Line railroad crossing.

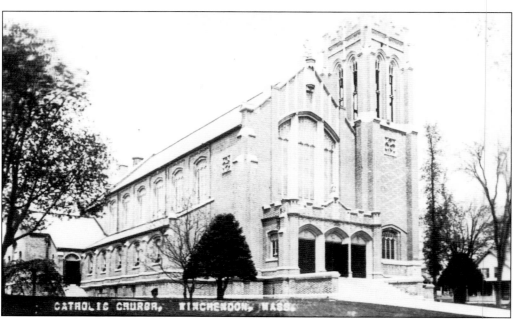

Pictured here is the Immaculate Heart of Mary Church, located at the corner of Spruce and Grove Streets. Construction was begun about 1871, when the basement of the church was roofed over, and masses were held in the basement pending the completion of the church as it appears today.

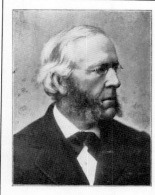

REV. DAVIS FOSTER, D.D.
PASTOR FOR 33 YEARS. DIED DEC. 12, 1901

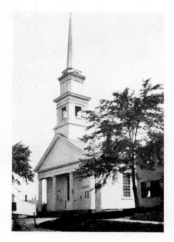

NORTH CONGREGATIONAL CHURCH
Photo by D. E. Norcross

REV. CHARLES C. MERRILL
PRESENT PASTOR

Rev. David Foster served as minister of the North Congregation Church for thirty-three years. The North Congregational Church was created in 1843 by a company of twenty-four who formed the Congregational Meeting House Company. On January 10, 1884, the church was dedicated. The Rev. Charles Merrill became pastor of the church in 1902 and organized many improvements of the church.

Pictured here is the North Congregational Church, located between the Whitney House and the Whitcomb House. The Whitcomb House in the foreground was moved down Front Street to a location next to the bridge over the Miller's River.

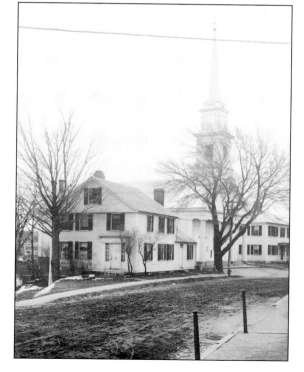

This is a view from Benjamin Hill with River Street in the foreground, c. 1890. Old Murdock High School can be seen in the center of the picture.

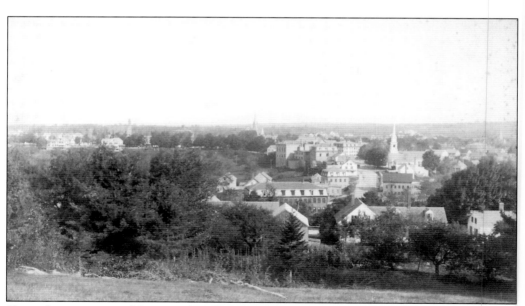

Shown here is a view of the town from Prospect Street, in a photograph taken before 1925. The church on the far right is the First Baptist Church, and the next one is the North Congregational Church on Front Street. In the center of the picture is the steeple of the Methodist church, and to the left of that is the tower of Old Murdock High School.

Five

Entertainment, Sports, and Organizations

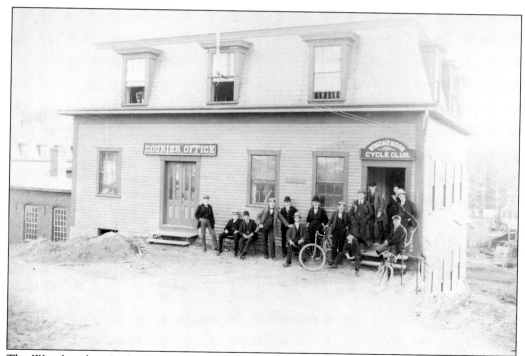

The Winchendon Cycle Club was organized in May 1894, and had its club rooms at No.3 Front Street, which was in the same building as the *Winchendon Courier*. Room Rule #4 for the cycle club stated "Members are requested to be as neat as possible and to be sure spit IN the cuspidors and not AT them."

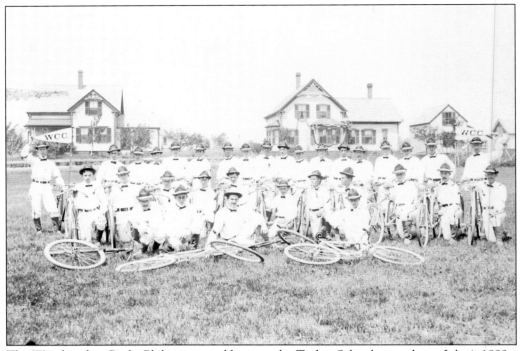

The Winchendon Cycle Club is pictured here on the Tucker School grounds, on July 4, 1899.

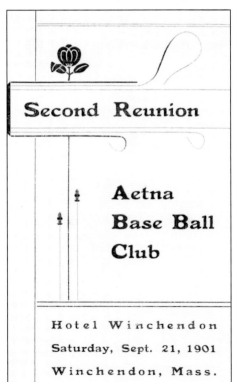

Second Reunion

Aetna
Base Ball
Club

Hotel Winchendon

Saturday, Sept. 21, 1901

Winchendon, Mass.

The Aetna Baseball Club held their second reunion at the Hotel Winchendon on Saturday, September 21, 1901. The reunion honored the Winchendon Team of 1886 and the Aetna Nine of 1886 with a record of 18–5.

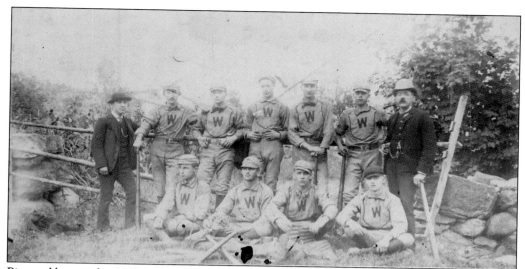

Pictured here is the 1886 Winchendon baseball team, featuring the following, from left to right: (front row) Fred Woodcock, first base and pitcher; John Pierce, third base and pitcher; Eddie Finn, catcher and third base; and the mascot; (back row) coach Arthur Folsom; Patrick Smith, right field; Daniel Hunt, short stop; Will Partridge, left field; Michael Condon, second base; Frank Corbin; and David McLoud.

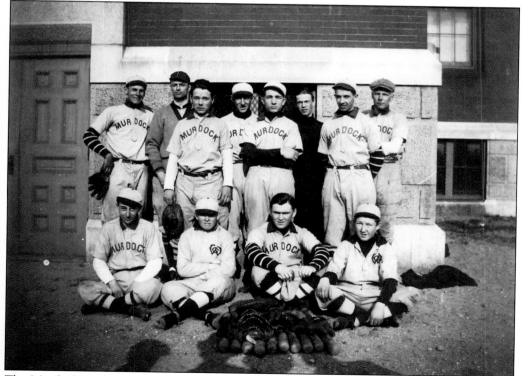

The Murdock High School baseball team is pictured in this c. 1910 photograph. The picture was taken outside of the Old Murdock High School on Grove Street.

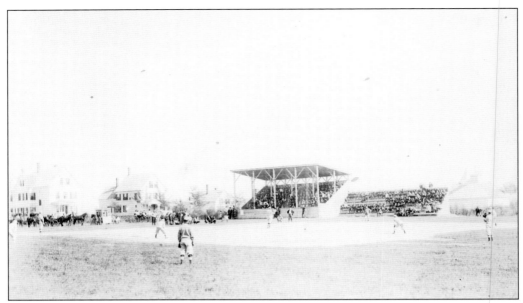

Here, the North Central Street ball park is pictured around 1911. Elisha Whitney had donated the park to the town.

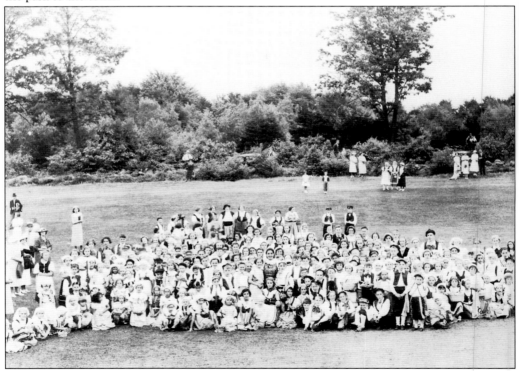

The Folk Festival of the highlands took place in June of 1937, on the grounds of the Toy Town Tavern. Andronike Mekelatos, who was the supervisor of music in the Winchendon schools, directed the festival. Eight hundred and thirty children in costume took part in the festival of folk songs, dances, and festival plays. The event was attended by thousands.

FESTIVAL EDITION
The Winchendon Courier

Our

Congratulations

to the

Music

Department

of the

Winchendon

Schools

ANDRONIKE MEKELATOS
Director 1936–1939

To Supt. Mitchell who has co-operated whole-heartedly with Miss Mekelatos, the director; to the teachers who have worked for the success of the Music Program in the Schools, and to the children who have spent hours in rehearsals.

The Folk Festival edition of the *Winchendon Courier* congratulated Andronike Mekelatos and the others who were responsible for the Folk Festival of 1937.

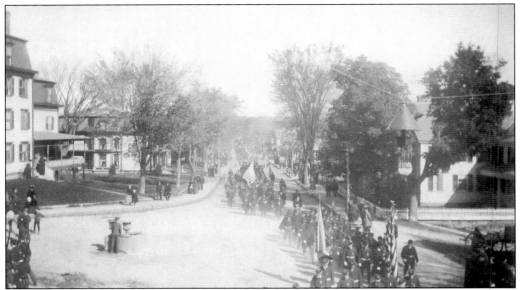

This photograph shows a parade on Central Street heading toward Front Street, about 1880, before Joseph's Store was built. On the left is the American House Hotel, in the center of the intersection is a watering trough put there around 1875, and at the top right is a gaslight. Gaslights were introduced to the town in 1875.

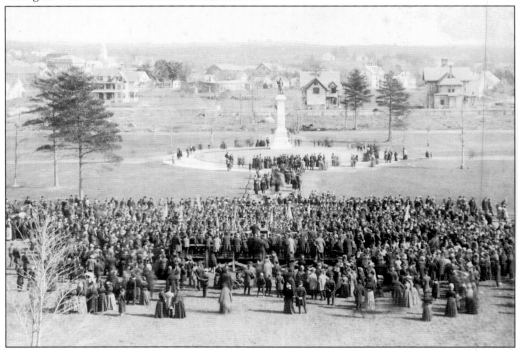

On Wednesday, October 16, 1889, the Soldiers' Monument by the old Murdock High School was dedicated. The monument was made possible by the efforts of the Gilman C. Parker Post No. 153, Grand Army of the Republic. The organization was made up of veterans of the Civil War, and when the last member died in 1935, the organization was disbanded.

DEDICATION

OF THE

SOLDIERS' MONUMENT,

On Wednesday, October 16th, 1889.

ALL VISITING ORGANIZATIONS will report upon arrival to Assistant Marshal, GEO. B. STONE, who will be in waiting at the Depot, and will be escorted to G. A. R. Hall by Gilman C. Parker Post, No. 153, for lunch.

The Line, composed of G. A. R. Posts, with the Selectmen, Committees, and Guests in carriages, will form on Front Street, right resting at the corner of Pleasant Street, at 10.15 o'clock, A. M., and will move at 10.30 o'clock through the following streets.

ROUTE OF THE PROCESSION:

Pleasant street to Grove, Central, Maple, Linden, North, Central, Front, School Square, School, Academy and Oak street to the Monument, arriving at 11.30.

EXERCISES AT THE MONUMENT.

Address of Welcome by the President of the day, ORLANDO MASON, ESQ.
Prayer by REV. DAVIS FOSTER.
Transferring the Monument to the Town, by the Monument Com., C. J. RICE, ESQ.
Unveiling the Monument,—selection by the FITCHBURG BAND.
Reception of the Monument by the Selectmen, J. H. FAIRBANK, Chairman.
Dedication by POST No. 153, G. A. R., H. A. STARKEY, Post Commander.
Address by GEO. L. GOODALE, Commander G. A. R., Department Massachusetts.
Oration by GEN. E. W. HINCKS, of Cambridge.

AT 1.15, DINNER.

Tickets to which will be furnished to Commanders of Posts and Companies, by the Entertainment Committee, Dr. N. R. Perkins, Chairman.

At 3.00 P. M., on the grounds of Baxter D. Whitney on Central Street, EXHIBITION DRILL and DRESS PARADE by the Heywood Guards of Gardner.
Followed by Band Concert by the Fitchburg Band.

If the day should be stormy, the services will be held in the Town Hall, immediately after unveiling the Monument.

This is a copy of the Soldiers' Monument dedication agenda.

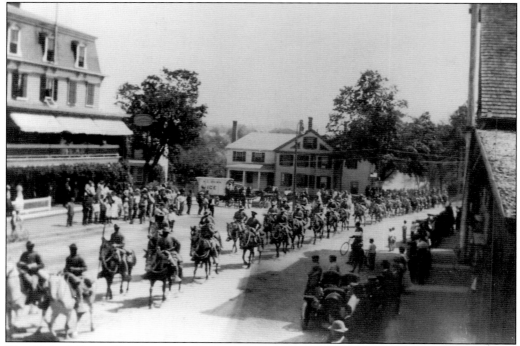

The United States Cavalry camped overnight on West Street in Winchendon in 1909. The American Hotel is on the left, with the old post office and the Murdock Building on the right.

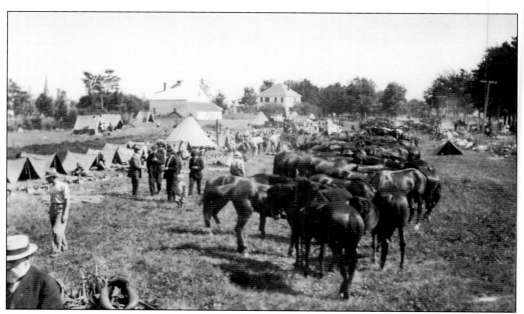

Pictured here is the United States Cavalry with their camp set up on West Street on August 27, 1909.

Big Town Wigwam, - Hunting Grounds of Winchendon.

EXEMPLIFICATION OF THE FOUR DEGREES.

Imp'd Order

of Red Men

Sleep of 7th Sun, Hunting Moon, G. S. D. 403,

UNDER THE AUSPICES OF

✳ WATATIC TRIBE No. 85. ✳

This was the program for a dinner and dance of the Watitic Tribe No. 85 of the Winchendon Red Men, c. 1900. The order of the Red Men traces its origin to certain secret patriotic societies founded before the American Revolution. They were established to promote liberty and to defy the tyranny of the English Crown. Among the early groups were the Sons of Liberty, the Sons of Tamina, and the Red Men.

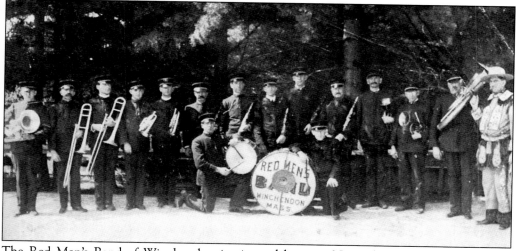

The Red Men's Band of Winchendon is pictured here on November 23, 1907, with M.D. Gay, manager.

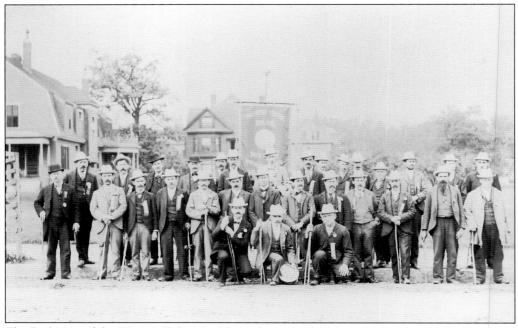

The Red Men of the Watitic Tribe No. 85 are shown in this photograph taken in Worcester on September 27, 1907. Meetings of the tribe were held upstairs in the Rome Block on the second and fourth Friday of each moon. The group was disbanded in the late 1930s with the onset of World War II.

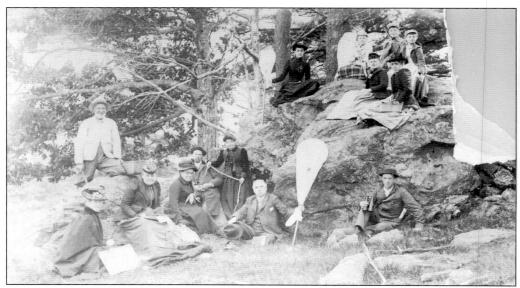

The Agassiz Association outing of June 27, 1891, is pictured here. The Agassiz Association was organized in Winchendon in 1890, and studied all the resources of the town connected with natural science. During their many outings, the members would collect specimens of curious plants and insects. This outing took place on Tolman Hill.

The St. Jean-Baptiste Society was organized to promote the interests of the French-Americans. The Winchendon branch was organized on May 21, 1905. The gentleman in the center of the picture with the gavel in his hand is Edouard Lemire, who was one of the charter members, and who also served as president of the organization.

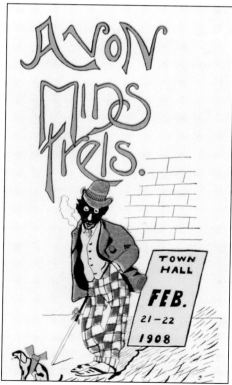

The town hall suffered a major fire on July 5, 1880, which destroyed the upper part of the building. In April of 1881 the town hall reconstruction was completed with the addition of an auditorium gallery and stage. There were many plays and social events held at the town hall, such as the appearance of the Avon Minstrels in 1908.

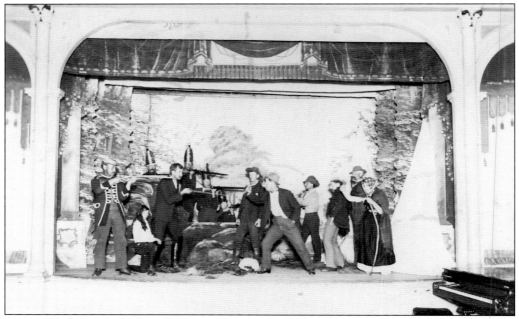

A play called *Neighbor Jackwood* was put on in the town hall auditorium sometime before 1925. The stage is quite ornate, with columns on either side and hardwood floors. The balcony is surrounded by a wrought iron rail which can still be appreciated today. The curtain above the stage was hand-painted and was damaged in 1925 when there was another fire at the town hall.

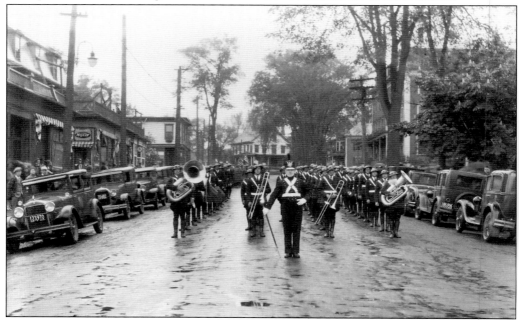

The American Legion Band was photographed on Central Street, about where Mathieu Ford is now located, c. 1930. The band leader was Jules Fournier, whose hat was a bright red. The band uniforms consisted of navy blue jackets and lighter blue pants with a red stripe running up the pant legs.

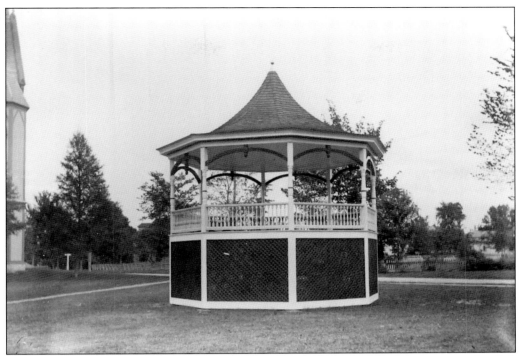

The Watitic Tribe No. 85 of the Winchendon Red Men sponsored band concerts at the Oak Street bandstand next to the Wheeler School. The bandstand is shown here about 1905.

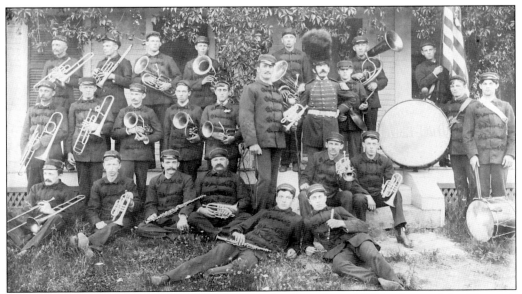

The Waterville Cadet band had their photograph taken about 1893 in front of the Hancock House in Waterville.

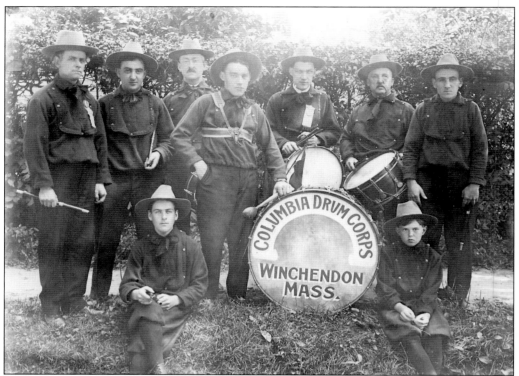

The Columbia Drum Corps are pictured here, c. 1900. The gentleman with the drumsticks and drum over the large drum is Harry Parks.

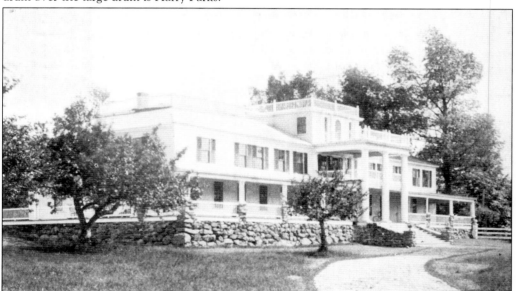

The property known as the Wyman Farm was purchased in 1899 by Morton E. Converse. He constructed a road through the property so the townspeople could enjoy the view. In 1912 he updated and added to the farmhouse and made it into a small hotel called the Toy Town Tavern. It was at this time that Winchendon began to acquire its identity as "Toy Town."

Mr. Henry Ward Wyman and his wife Seraphina (Forbush) Marshall. The Wyman Farm was built in 1786 by Simeon Sterns. At one point it was the Toy Town Tavern; it is now the Winchendon School.

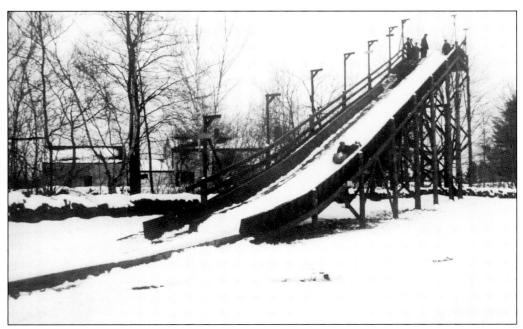

The Toy Town Tavern was a summer resort offering golf, tennis, and horseback riding. The tavern offered entertainment in the winter as well, featuring a ski jump and a toboggan slide.

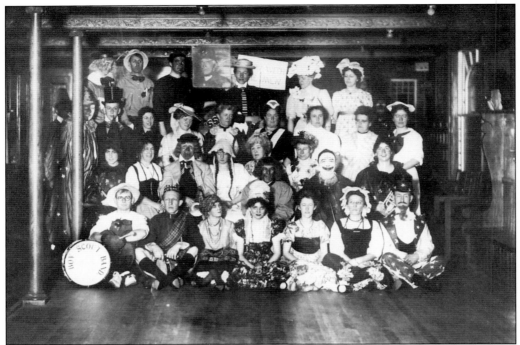

Shown here is a costume party given by Grace (Converse) Cross, in 1913, at the casino in Morton Converse's house on Front Street. Grace Atherton Converse married Dr. Cross.

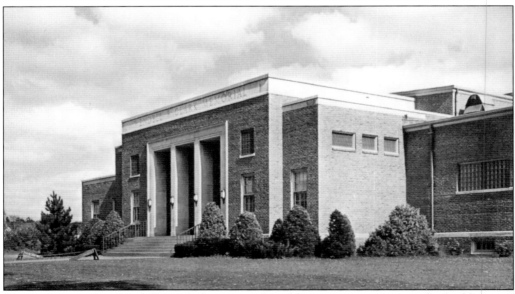

Shown here is the Wendell P. Clark Memorial Building. Construction on the building was begun in 1953 and completed in 1954. Wendell P. Clark, a resident and manufacturer of chairs for over fifty years, left a trust fund of $215,000 at his death in 1919 for the construction of a community house for the benefit of the inhabitants of Winchendon. The Clark Memorial, located on Central Street, features a gymnasium, pool, tennis courts, and many other recreational facilities.

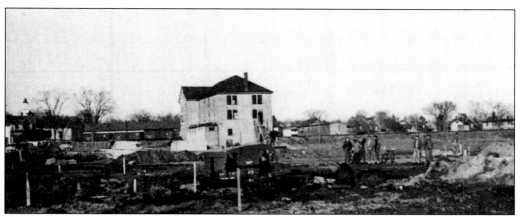

The trustees of Mr. Clark's trust fund were instructed to invest the money and to support Mr. Clark's widow.

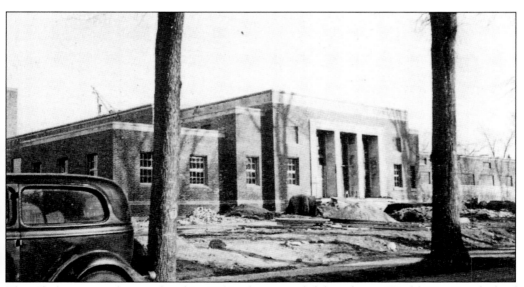

The Clark was mostly completed in 1954, after several delays due to World War II, a lack of materials, and pending litigation between the heirs of Mr. Clark and the trustees of the estate.

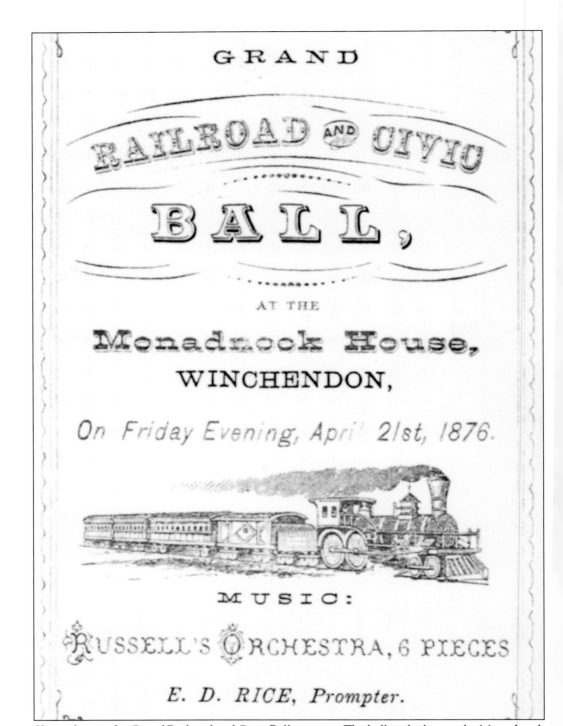

GRAND

RAILROAD AND CIVIC

BALL,

AT THE

Monadnock House,

WINCHENDON,

On Friday Evening, April 21st, 1876.

MUSIC:

RUSSELL'S ORCHESTRA, 6 PIECES

E. D. RICE, Prompter.

Shown here is the Grand Railroad and Civic Ball program. The ball took place at the Monadnock House on Friday evening, April 21, 1876. This was printed by Franklin W. Ward, owner of the *Winchendon Courier*.

Six

Professional Individuals of Winchendon

The Miller's River Hospital is pictured here about 1907. Abe Smith is in the buggy, and Ruth Henry, daughter of Dr. Henry, is in the Stanley Steamer. Three nurses—Mrs. Shimmer, Helen Read, and the first head nurse, Donna Wyatt—are also pictured, and standing next to them are Burt Thorning and Dr. J.G. Henry. The hospital was located at 33 Pleasant Street, across the street from the Beals Memorial Library.

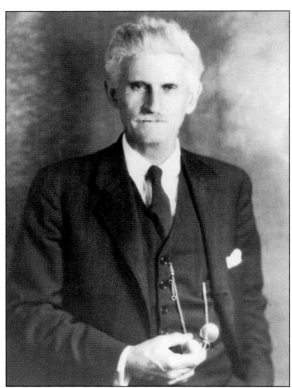

Dr. John Goodrich Henry, M.D., was one of the founders of the Miller's River Hospital. The hospital was opened in 1907.

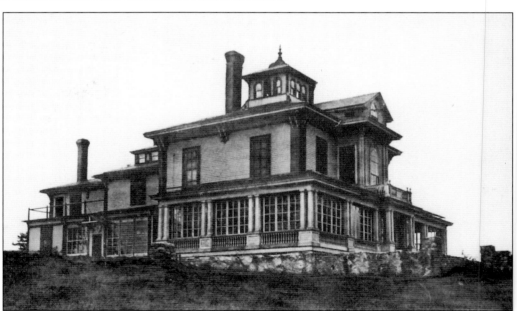

In 1875, Doctor Ira Russell established the Highlands Hospital at 61 High Street. It was formed for the treatment of nervous and mental disorders. In 1882, Dr. Frederick Russell joined his father at the Highlands. He became chief physician and proprietor of the Highlands with the death of his father in 1888.

Doctor Frederick Russell was the president of the Agassiz Association and had a love of entomology. His collection of moths and butterflies can be seen at the Winchendon Historical Society.

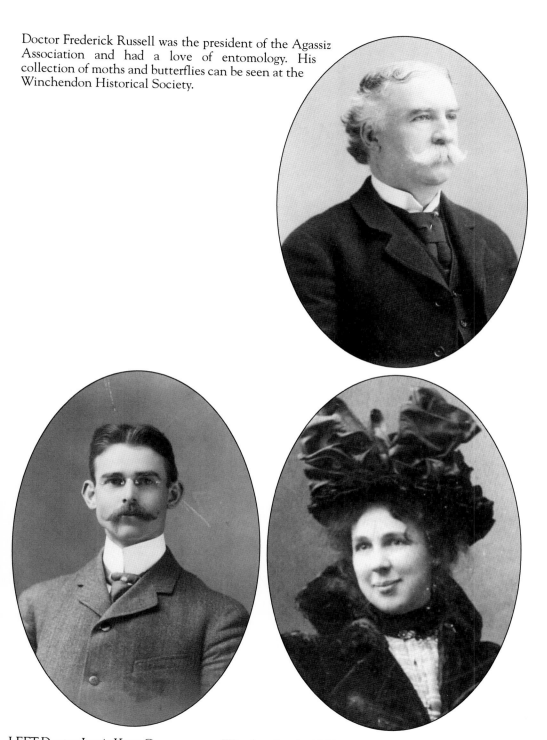

LEFT:Doctor Louis Kent Cross came to Winchendon in 1901 to practice medicine. He married Grace Atherton Converse, the daughter of Morton E. Converse, and resided on the corner of Front and Academy Street. RIGHT: Mrs. Louis K. Cross (Grace Atherton Converse).

A view from Academy Street, looking north from Front Street in the early 1900s. Dr. Cross's house is on the left, and the Wheeler School is at the end of the street.

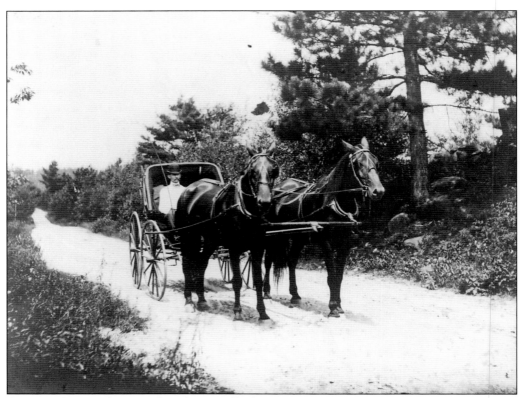

Dr. Louis Cross is shown making house calls about 1904.

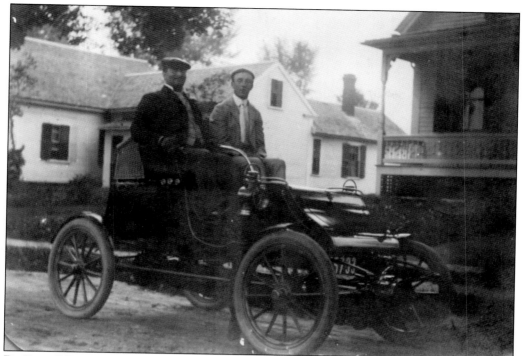

Dr. Peter S.W. Geddes was photographed in his Stanley Steamer in front of his house on School Street in the early 1900s. Dr. Geddes had a practice in Winchendon for over thirty years.

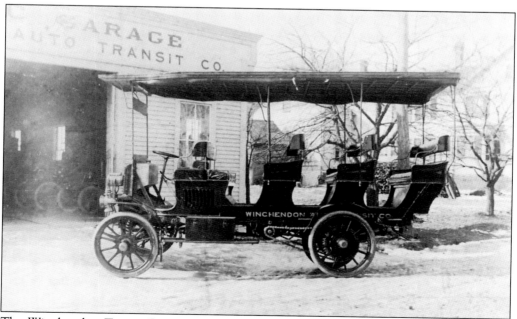

The Winchendon Transit Company was organized in the first decade of the 1900s. John P. Bartlett and Charles A. Andrews' bus service had its garage on Railroad Street. Some of the busses were not enclosed, but had side curtains that could be put down in bad weather.

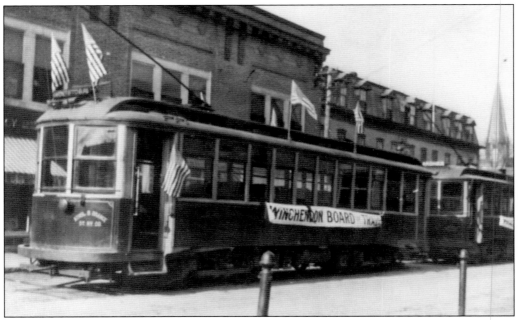

In 1912 the Winchendon Board of Trade gave its approval for trolley service for Winchendon, and on September 24, 1912, the first trolley appeared on Central Street. The trolley is parked on Central Street, and the front of it reads "Athol and Orange St. Rw. Co."

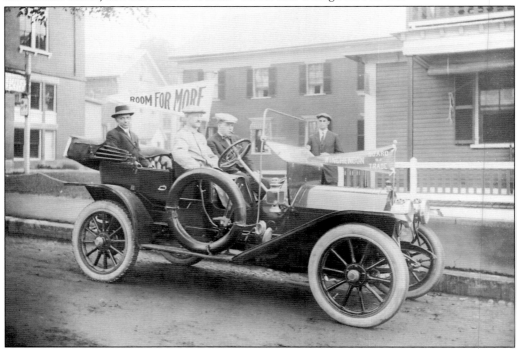

E.H. Pierce was photographed at the wheel of a 1910 Cadillac in front of the American House Hotel. Bob Brooks, a barber, is next to the driver. Chris Campbell is in the rear and Howard Elliot is standing on the sidewalk.

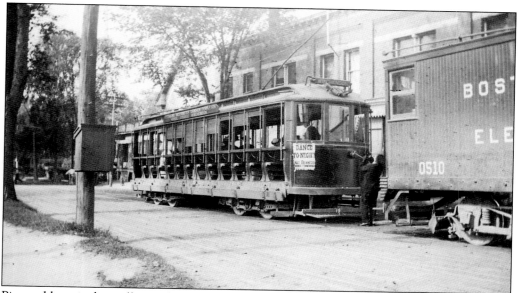

Pictured here is the trolley at the corner of Central and Railroad Streets, as it is about to start its route.

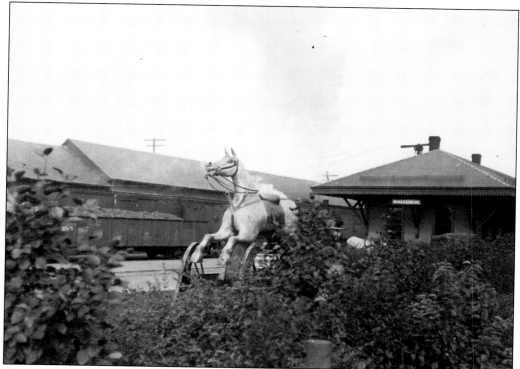

The B. & M. Railroad station was located on Central Street, where Brooks Pharmacy is now located. On May 15, 1848, the road to Keene was officially opened by the Cheshire Railroad. The original Toy Town Horse was placed next to the railroad station after the parade of 1914 and remained there for twenty years.

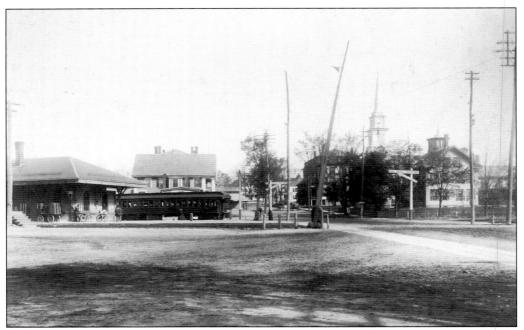

This photograph from around 1896 shows the Winchendon Railroad Station and the Worcester Train. The house after the railroad crossing sign was called the Mansion House and was owned by John Bourgeault. The steeple of the First Baptist Church can be seen and just after it is the Winchendon Hotel.

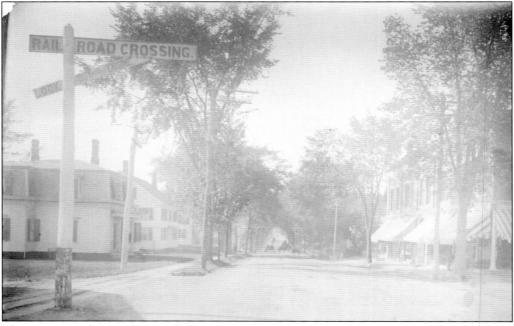

This is a view of Central Street looking toward Front Street from the railroad station, c. 1900. Durgin's Pharmacy is on the right. The sign on the left below the railroad crossing says "Look Out for the Engine."

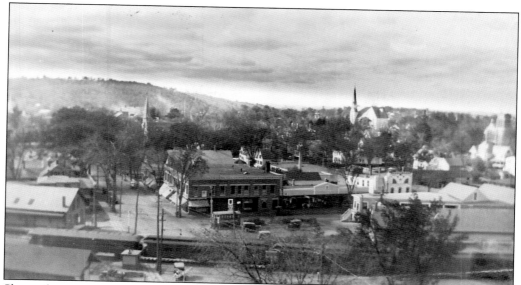

Shown here is a view of Central Street taken from the steeple of the Baptist church about 1925, showing the morning train from Boston. On the corner of Central and Railroad Streets is Durgin's Pharmacy. From left to right are the North Congregational Church, the Church of the Unity, the Methodist church, and the Catholic church.

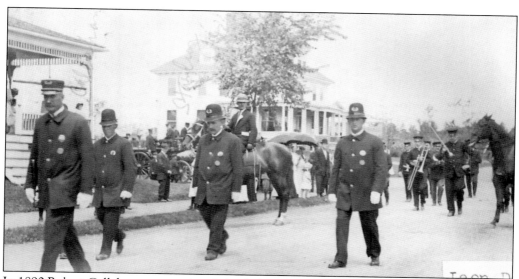

In 1890 Robert Callahan was appointed chief of police and was put in charge of two constables. In the early 1900s the force had grown to eight constables, who patrolled the community mainly on foot. Chief Robert Callahan is on the left with Tim Murphy behind him.

In 1886 Robert Callahan began his police duty in Winchendon, after he was elected constable at the annual town meeting. In 1890 he was appointed chief of police, and continued in this capacity until 1937. Mr. Callahan married Mary E. Donnelly of East Jaffrey, New Hampshire, and was the father of five daughters. He was also a member of the board of health, the school board, and was vice-president of the Winchendon Cooperative Bank.

The Alert Fire Engine Company was started about 1851 and had one hand pumper. In 1870, the town purchased its first steam fire engine, and as a result new quarters were needed. In 1876 the town voted to build a fire station on Pleasant Street in back of the town hall. The Alert Fire Engine Company was housed in the rear of the building and had forty-four men attached to it.

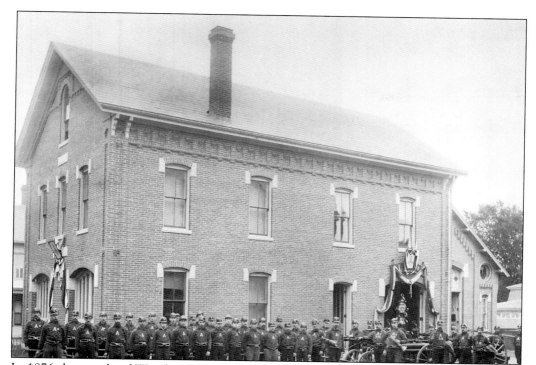

In 1876 the people of Winchendon voted to build a fire station on Pleasant Street, to house Steamer Company No. 1, with an attachment of twenty men. The Alert Fire Engine Company, pictured above, was housed in the rear of the building, and had an attachment of forty-four men and one hand fire engine. The building is now the police station.

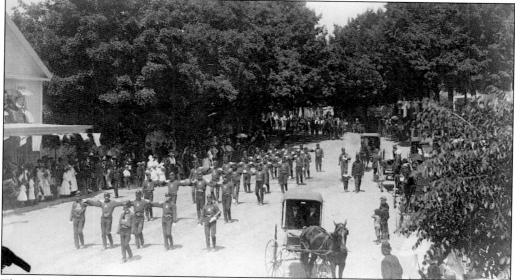

The Alert Fire Engine Company is pictured here in the July 4, 1888 parade. According to Baxter Whitney's ledgers of 1867 to 1870 he did work on one of the hand pumpers of the Alert Engine Company. The total cost on March 20, 1869, was $1.30, on October 6 it was $13.70, and October 21 was $6.75, for a total of $21.75, which was paid in cash on February 22, 1870.

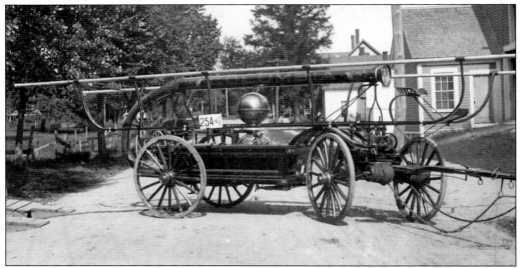

This c. 1900 photograph shows the hand tub Columbia on Beech Street in Winchendon. The Columbia competed in firemen's musters throughout the state, with the winner being determined by the distance which a stream of water was thrown. In forty musters from 1898 to 1908 the total money won was $4,210, with the average distance of the stream of water being 197 feet.

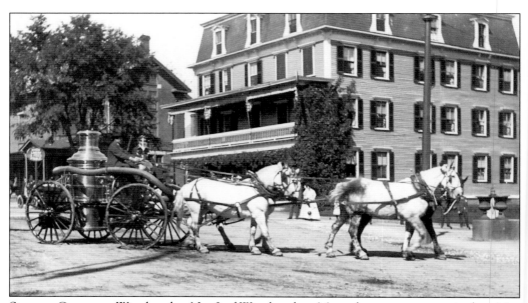

Steamer Company, Winchendon No. 2 of Winchendon, Massachusetts, was organized on May 14, 1891. This picture was taken in front of the American House Hotel, and in the background you can see the town hall. In 1891 there were thirteen fire alarm boxes in town: #28 Waterville, #38 Woodcock & Son, #42 M.E. Converse & Co.'s mill, #43 Steam Mill, #45 corner of Central and Maple Streets, #46 B.D. Whitney's shop, #47 G.N. Goodspeed's shops, #49 American House Square, #55 Centerville, #56 School Square, #64 Glenallen, #68 Winchendon Springs, and #134 Bullardville.

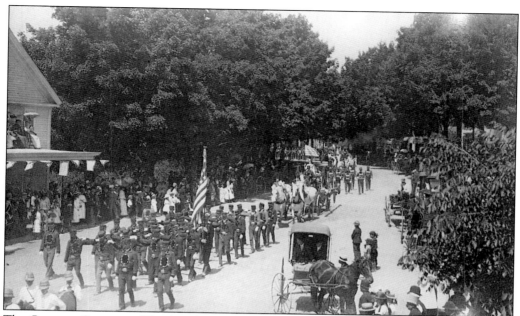

The Steamer Company, Winchendon No. 1, is shown here in the Fourth of July parade of 1888. The company was housed in what is now the building occupied by the Winchendon Police Department.

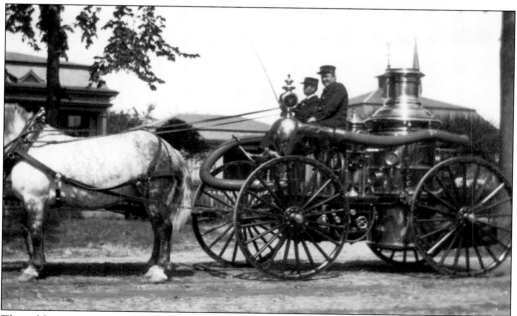

The old steamer is pictured in this c. 1890 photograph, along with Albert Peabody and Guy Clark.

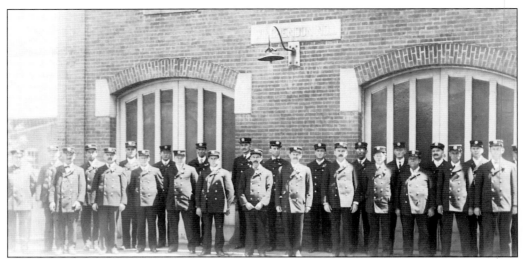

This *c.* 1900 photograph shows the fire department, located on Pleasant Street behind the town hall. This was the home of the Winchendon Steam Company No.1.

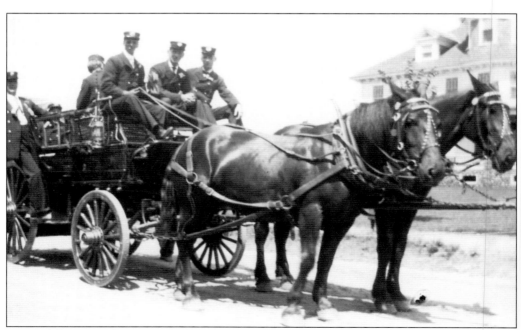

Pictured here is a hose cart with Mr. George Lacy, Mr. Enright, and Frank Martin in the driver's seat.

Seven

Winchendon and What Lies in Its Boundaries

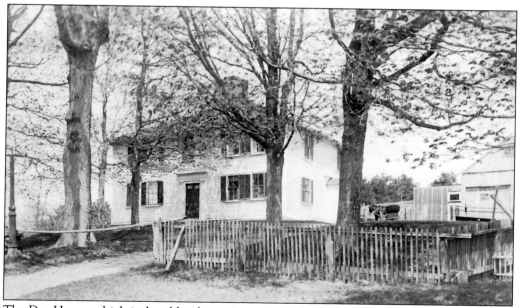

The Day House, which is the oldest house in town, was built around 1752 by Richard Day. The house is located on the right side of Hale Street on Old Center and is the location of the first town meeting, held in 1764. Day was one of the first settlers of Winchendon and was killed in 1774 by a falling tree.

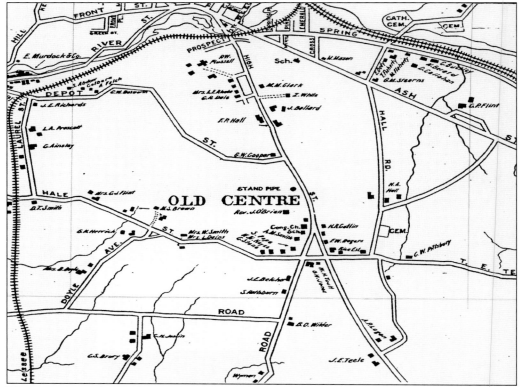

This is a map of Old Center from 1906, showing Rev. J. O'Brien's house off High Street. Rev. O'Brien's home is now the Winchendon Health Center. The First Congregational Church has the school located next to it and the old cemetery is on Hall Road.

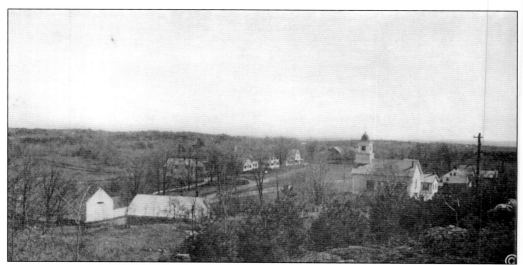

Pictured here is a view of Old Center with the First Congregational Church on the right, the Common in front of the church, and the parade grounds to the left.

This plaque designated Old Center as a historical district.

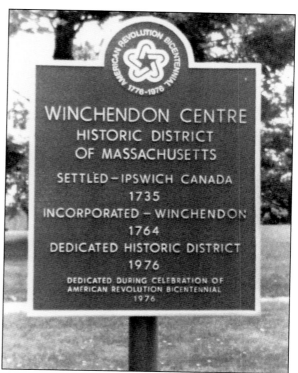

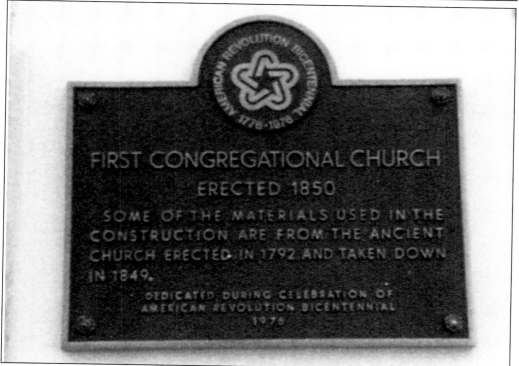

Shown here is the plaque on the First Congregational Church in Old Center.

Pictured here is the Common at Old Center, showing on the bottom left the stone commemorating the first church in Winchendon. The plaque on the stone reads "Here Stood the First Church in Winchendon, Erected 1762."

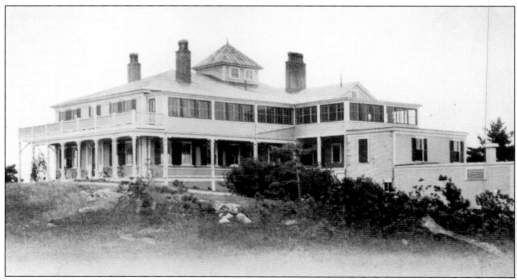

In 1918 the town of Winchendon purchased Rev. J. O'Brien's property, off High Street, for the purpose of a town home. The property is now the site of the Winchendon Health Center.

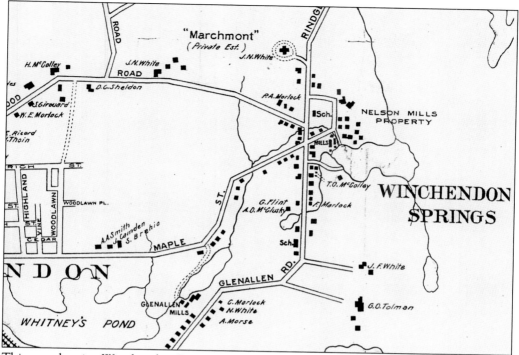

This map showing Winchendon Springs dates to 1906. At the top center was where Marchmont was located. Today, all that remains of Marchmont is the cellar hole and foundations of the other outbuildings. To the right of Whitney's pond, off Glenallen Street, is the location of one of the White's Mills, the Glenallen Mill.

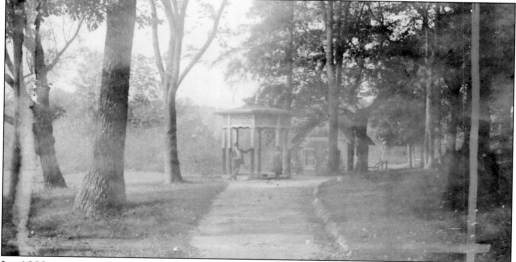

In 1889 a post office was established in Spring Village and the name was changed to Winchendon Springs. Winchendon Springs got its name from a spring which was located at the foot of Mill Circle and was a source of water for those living in the neighborhood. In the early 1900s there was a springhouse and bathhouse erected, since the water was believed to have healing powers.

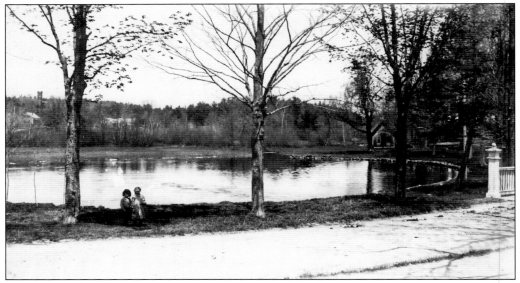

This is the pond at the bottom of Mill Circle as it looked around 1900. At the middle left of the picture, Marchmont's tower is visible.

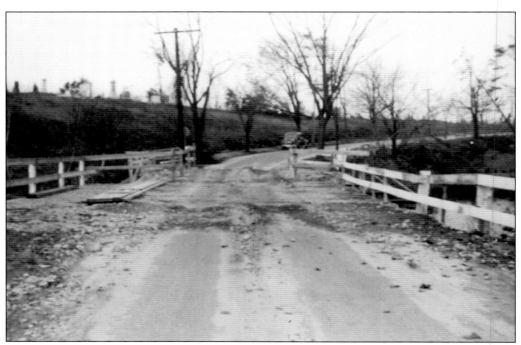

This is the bridge going from Spring Street to Glenallen over the Miller's River, or part of Whitney's Pond. In 1938 it was apparently called Winchendon Springs Road, although on the map it was referred to as Glenallen. The Catholic cemetery is visible on the left.

This map, dated 1906, shows Waterville (bottom right) and Bullardville (top center). It is presumed that Bullardville got its name from Charles Bullard, who lived there and had a small mill site there in the early 1800s. On the bottom right, next to the Miller's River, is the factory of E. Murdock and Company.

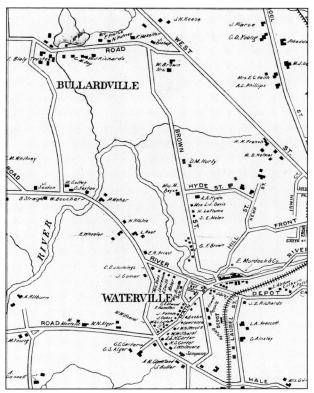

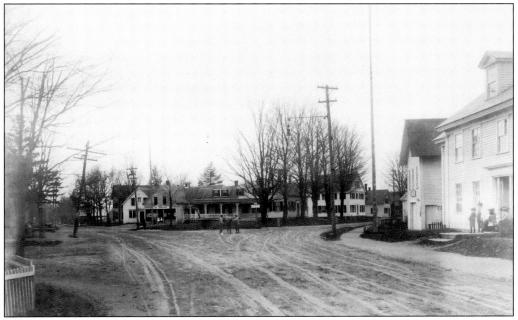

Shown here is the square at Waterville, *c.* 1900, with River Street on the right and Main Street on the left. The building on the right next to the tall pole was an engine house, which housed the hand fire engine "The Fountain," with thirty-eight men attached.

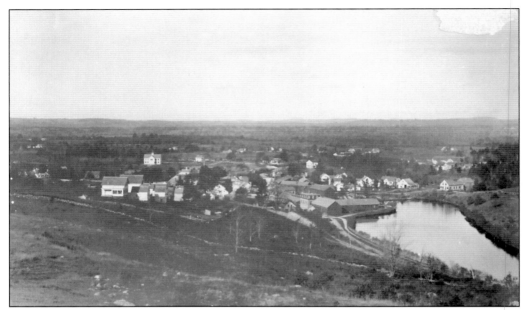

This is a view of Waterville from Benjamin Hill, with the Whitney factory and pond on the right.

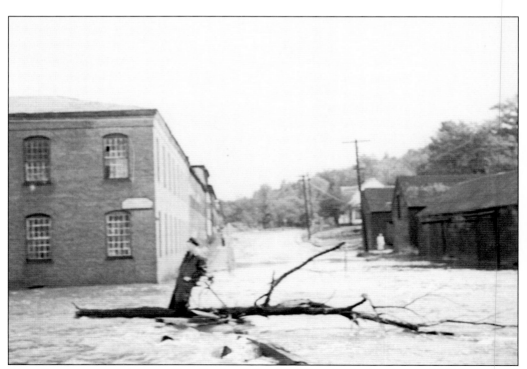

River Street next to what was New England Wooden Ware, in the hurricane of 1938.

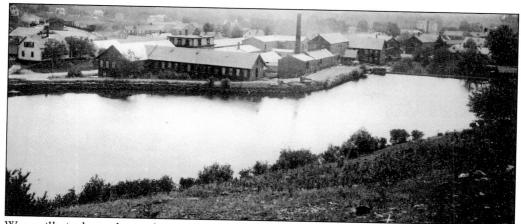

Waterville is shown here, about 1885. The factory by the river, that of William Whitney, was established by Elisha Murdock.

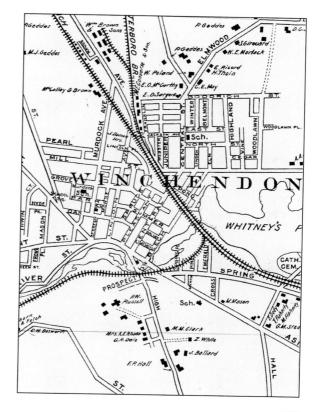

This map from 1906 shows the center of town. The railroad station was located just about where the "H" is in Winchendon. On Central Street, between North and East Street, was the Tucker School. Today, the fire station is located there.

Central Street, shown here in 1885, was described as one of the most delightful streets in the village—broad, straight, and in the summer nearly arched with shade trees.

This is a view of Central Street, taken in the late 1880s, looking toward Front Street. The Hotel Winchendon is on the left.

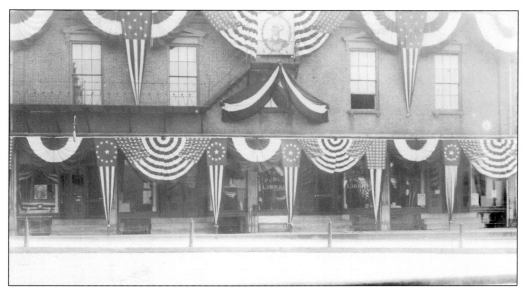

In 1887, the town hall housed the library, which contained 1500 books. The library was located in the center of the building, and the printing in the window reads "Free Public Library." The Beals Memorial Library was dedicated in 1913. The town hall was probably decorated here for the Fourth of July.

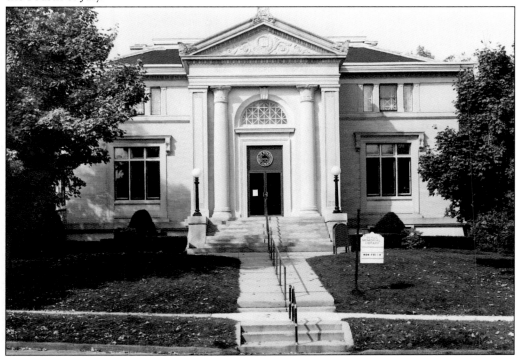

Beals Memorial Library, located on Pleasant Street, was dedicated in the afternoon of September 30, 1913. Mr. Beals gave the town of Winchendon $25,000 for the purpose of building a public library. The library would be called the Beals Memorial Library, in memory of his wife, Hattie M. Beals, and George L. Beals and family.

At the Town Hall at Two-thirty

PIANO SELECTION

Mrs. Elmer E. Pierce

INVOCATION

Rev. Charles Ernest White

PRESENTATION OF KEYS

Selectman Charles M. Day

ACCEPTANCE

Dr. John G. Henry, for the Trustees

ADDRESS

Ex-Gov. John D. Long of Hingham

PIANO SELECTION

REMARKS

Warren F. Gregory

of the Lothrop, Lee & Shepard Company, Boston

POEM

Written by James Raymond Perry of Chicago

Read by Mrs. Murdock M. Clark

REMARKS

Principal Hervey S. Cowell

of Cushing Academy, Ashburnham

PIANO SELECTION

On the Library Steps at Four-thirty

DEDICATORY PRAYER

Rev. Joseph F. Fielden of Fitchburg

The dedication of the Beals Memorial Library took place on September 30, 1913 at the town hall. The first library was in Old Center before 1800, and was kept by Joshua Smith.